Sonoma County, California, lies north of San Pablo Bay, part of the greater San Francisco Bay area, and is famous for its world-class wines, incredible sea shores, geysers, and, possibly less known for its stone quarries, the number of which lies in the hundreds. These quarries supply the world with slate patio stones, kitchen counter tops, and other hard-rock necessities including those used in building extremely sturdy homes and larger structures. The marbling of its many varieties of stones often produces fine art the beauty of which I have attempted to capture herein. The occasionally blurred images or parts of images are intentional, not happenstance, as I find the sense of motion quite disarming.

The Stones Of Sonoma County

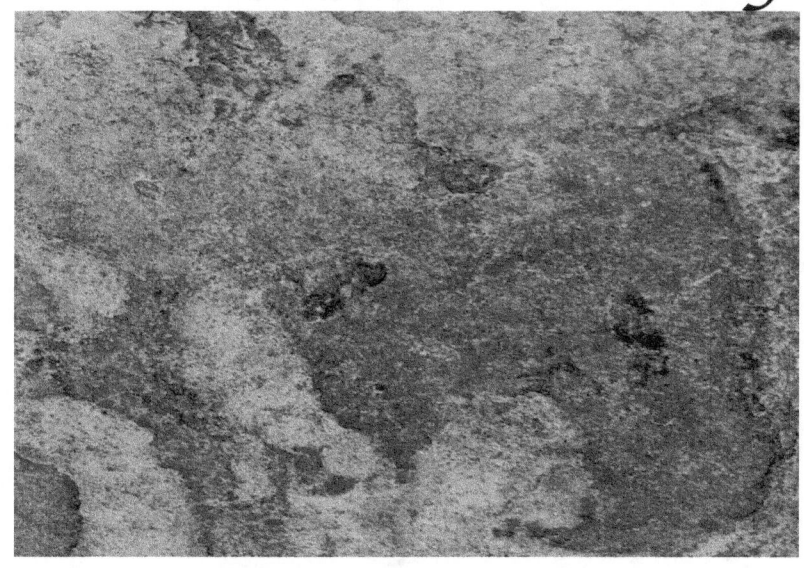

Photographs By David Cope

The Stones of Sonoma County
Photographs by David Cope

Epoc Books
Printed in the United States of America
© David Cope 2016
All Rights Reserved.
Published 2012.

The characters and events in this book are fictitious.
Any similarity to real persons, living or dead, is coincidental
and not intended by the author.

This book is dedicated to my wife, sons, and grandchildren, Zoe, Tess, Gavin, and Ethan whose excitement for everyday things never ceases to amaze me. And to those older kids like me who believe in those children.

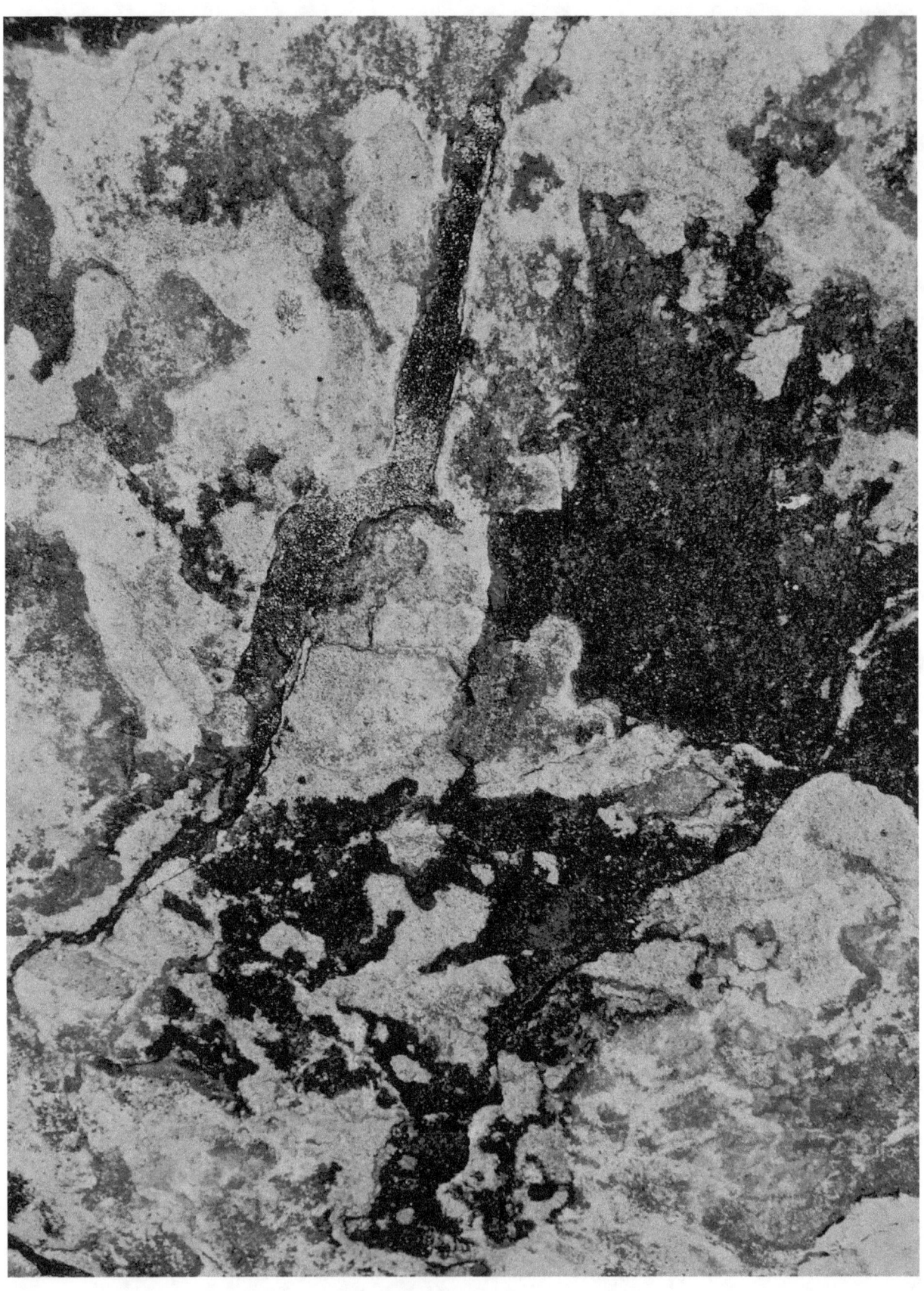

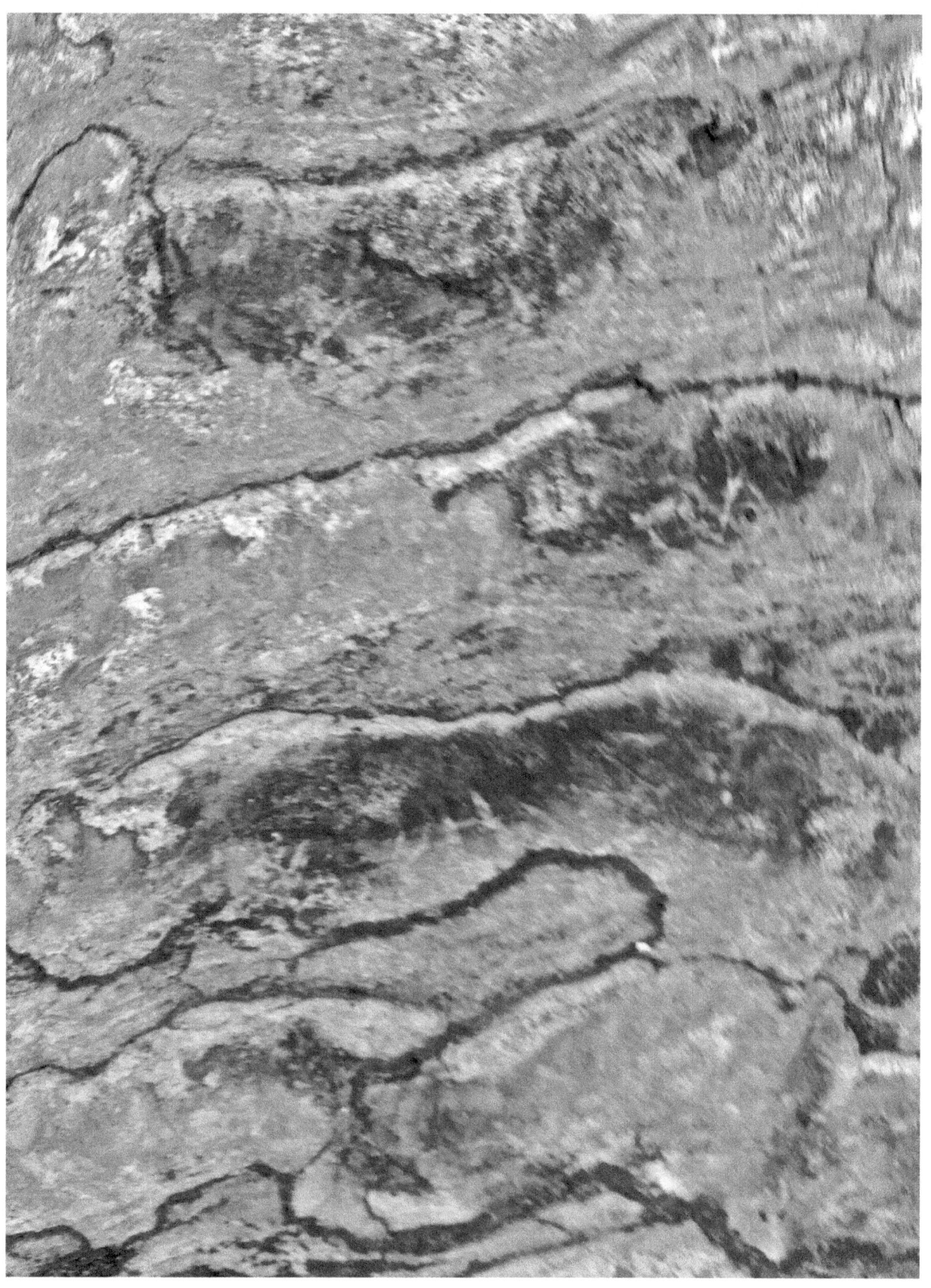

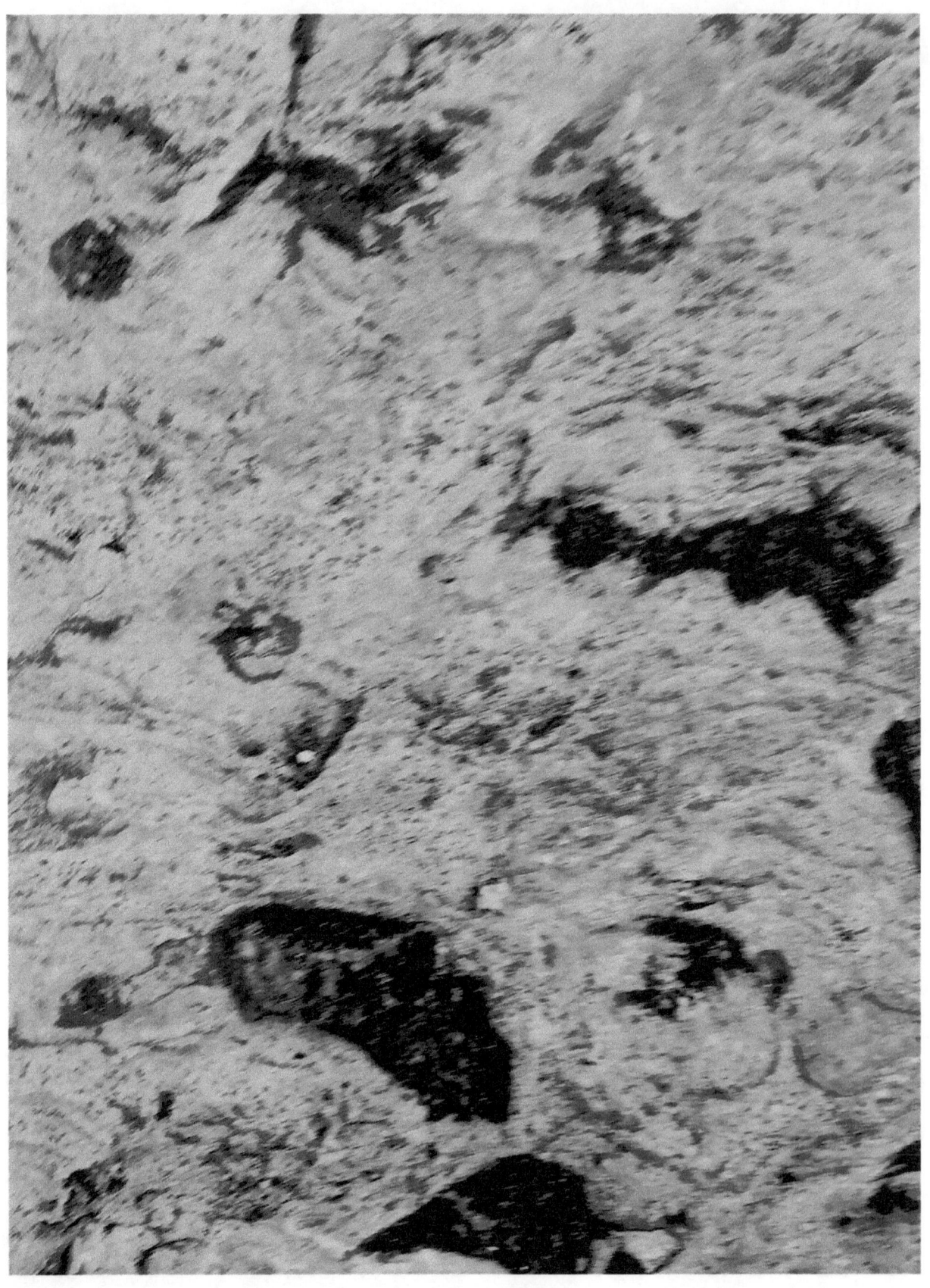

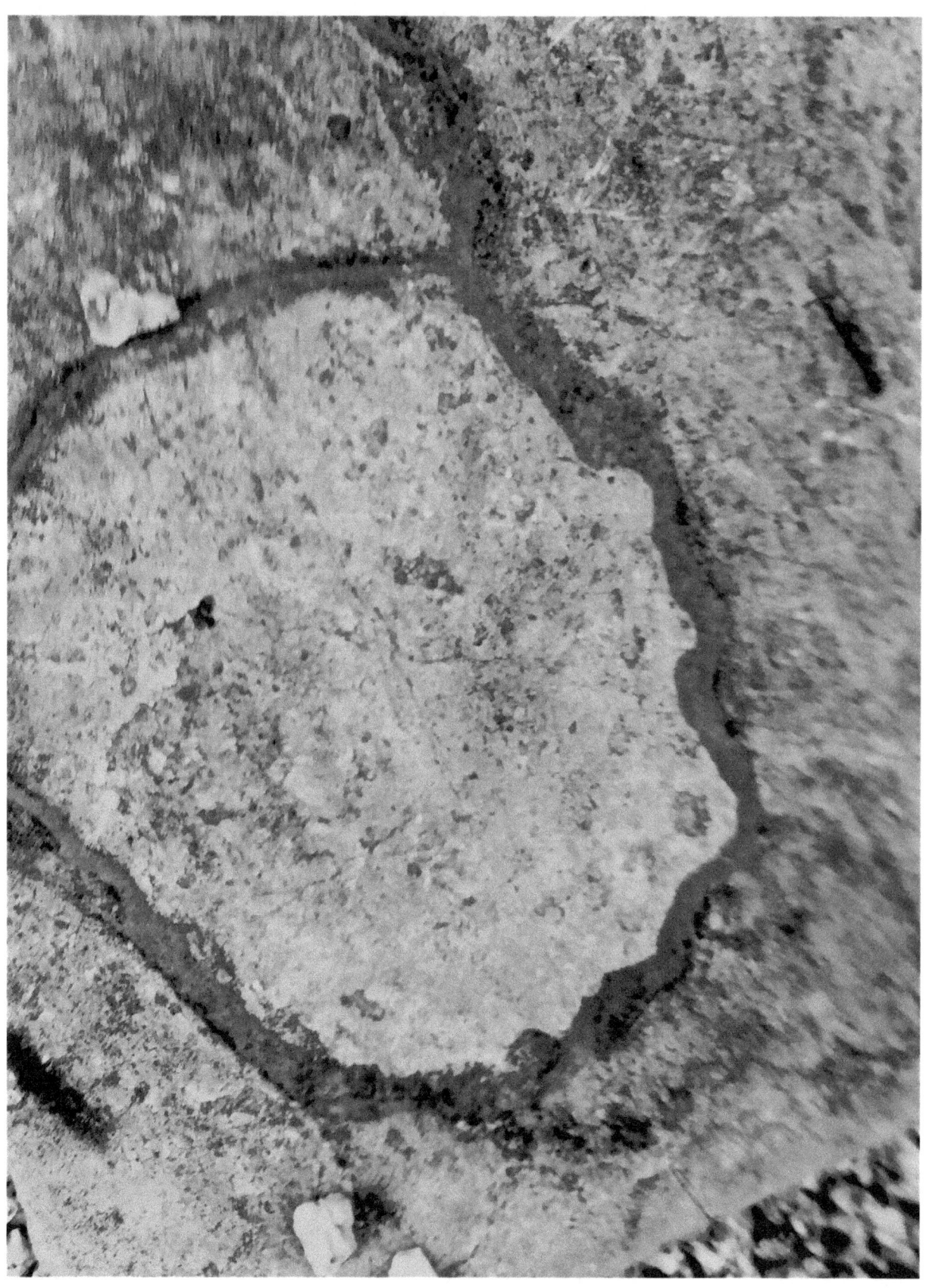

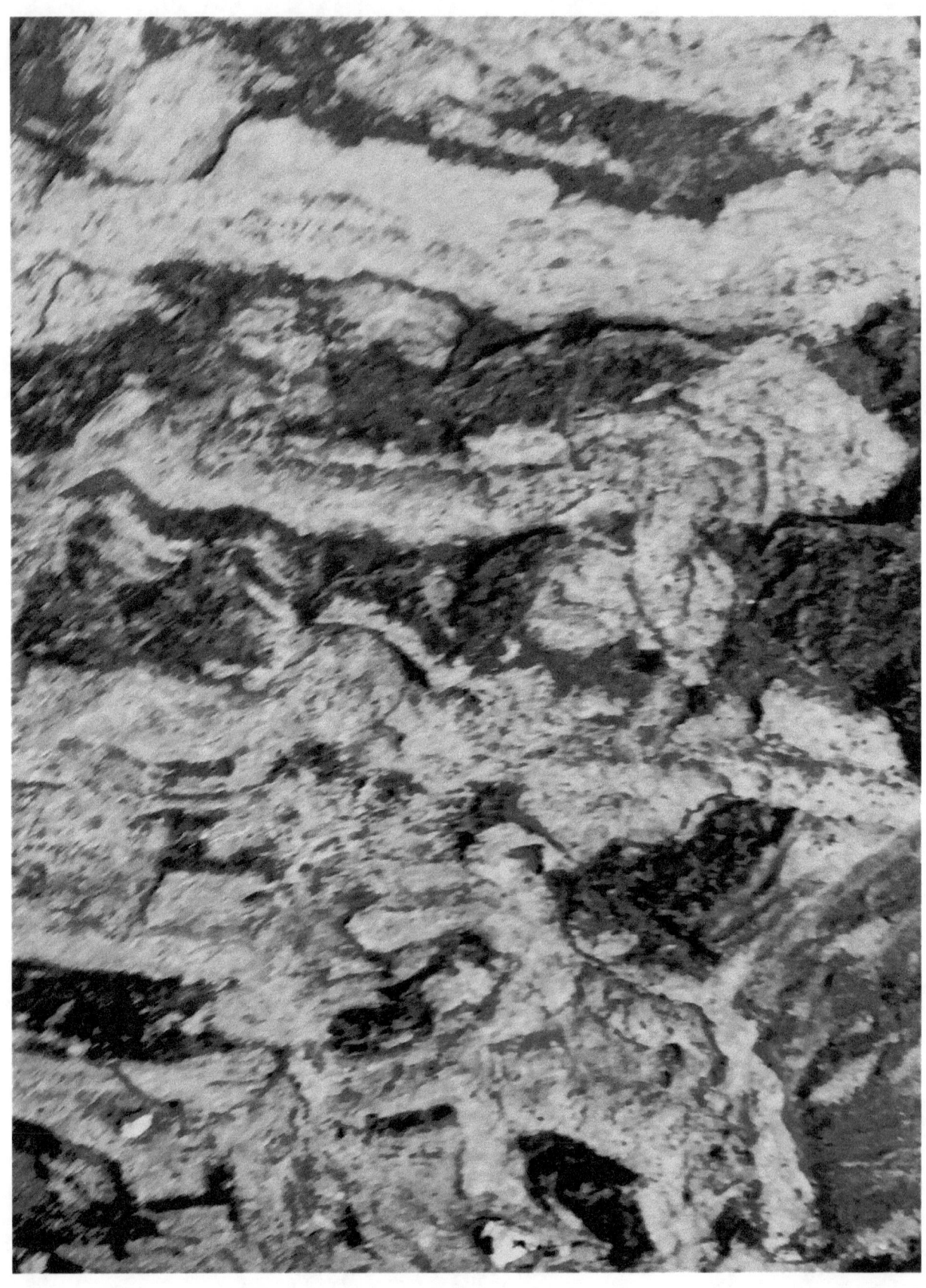

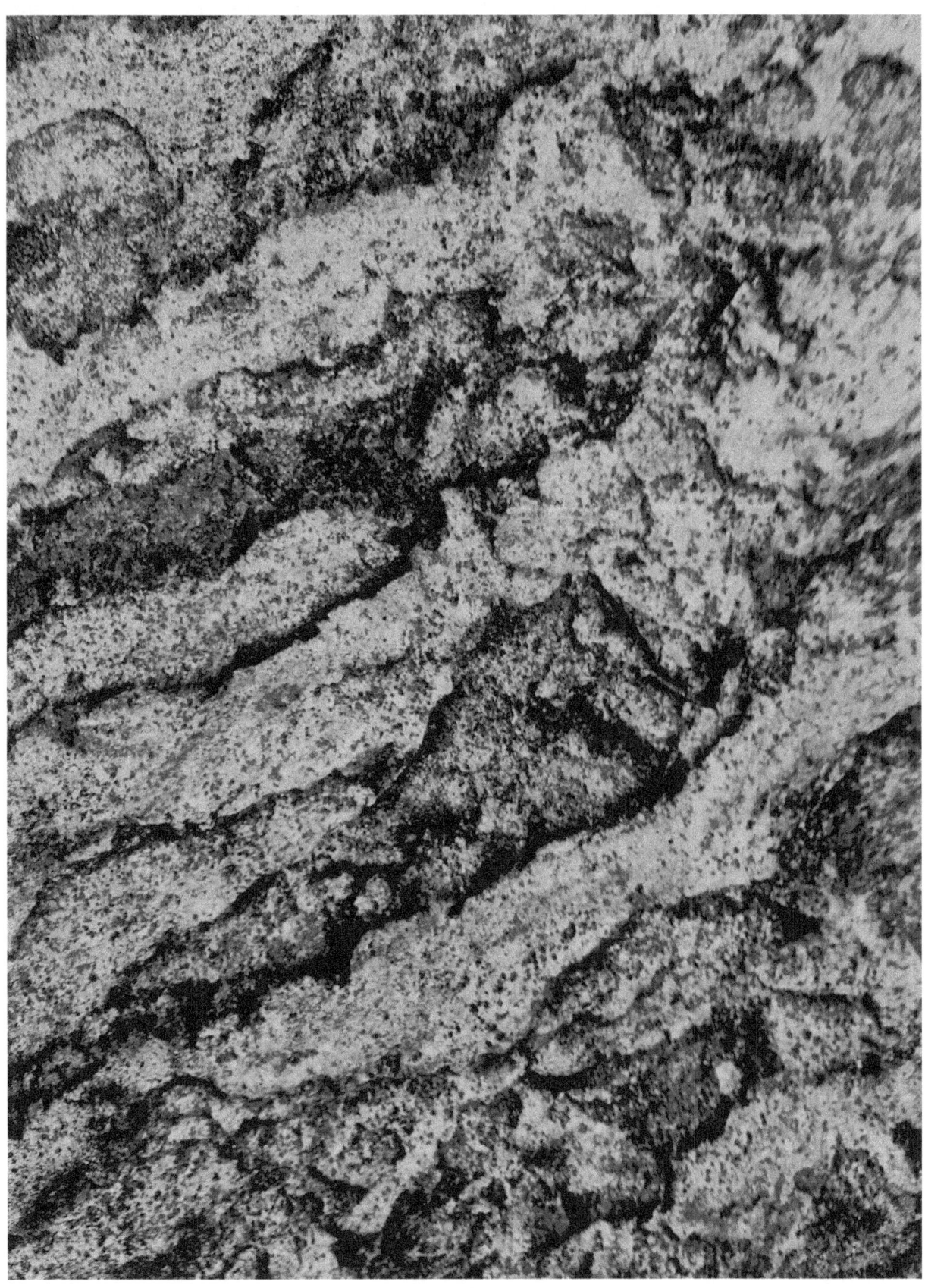

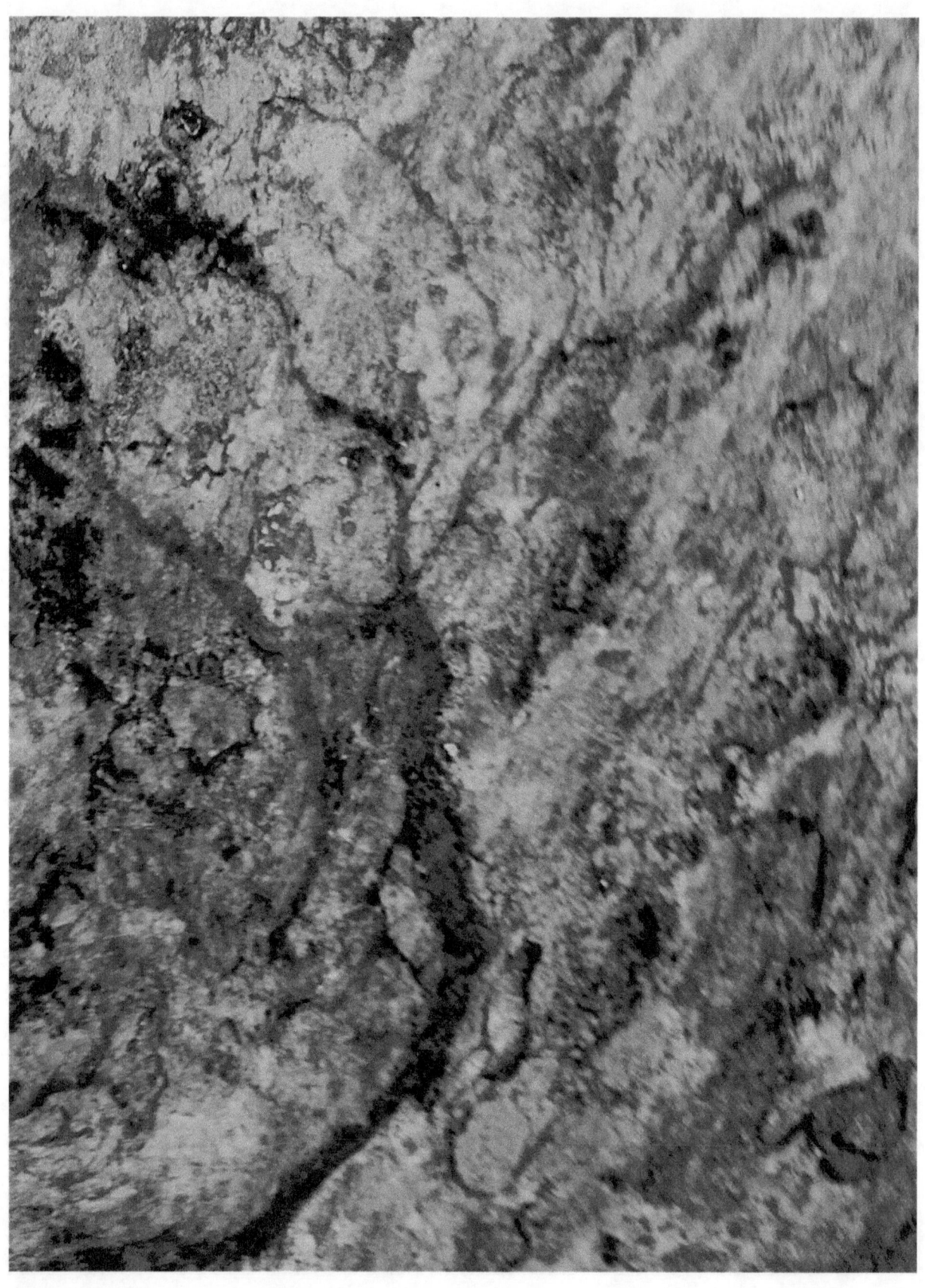

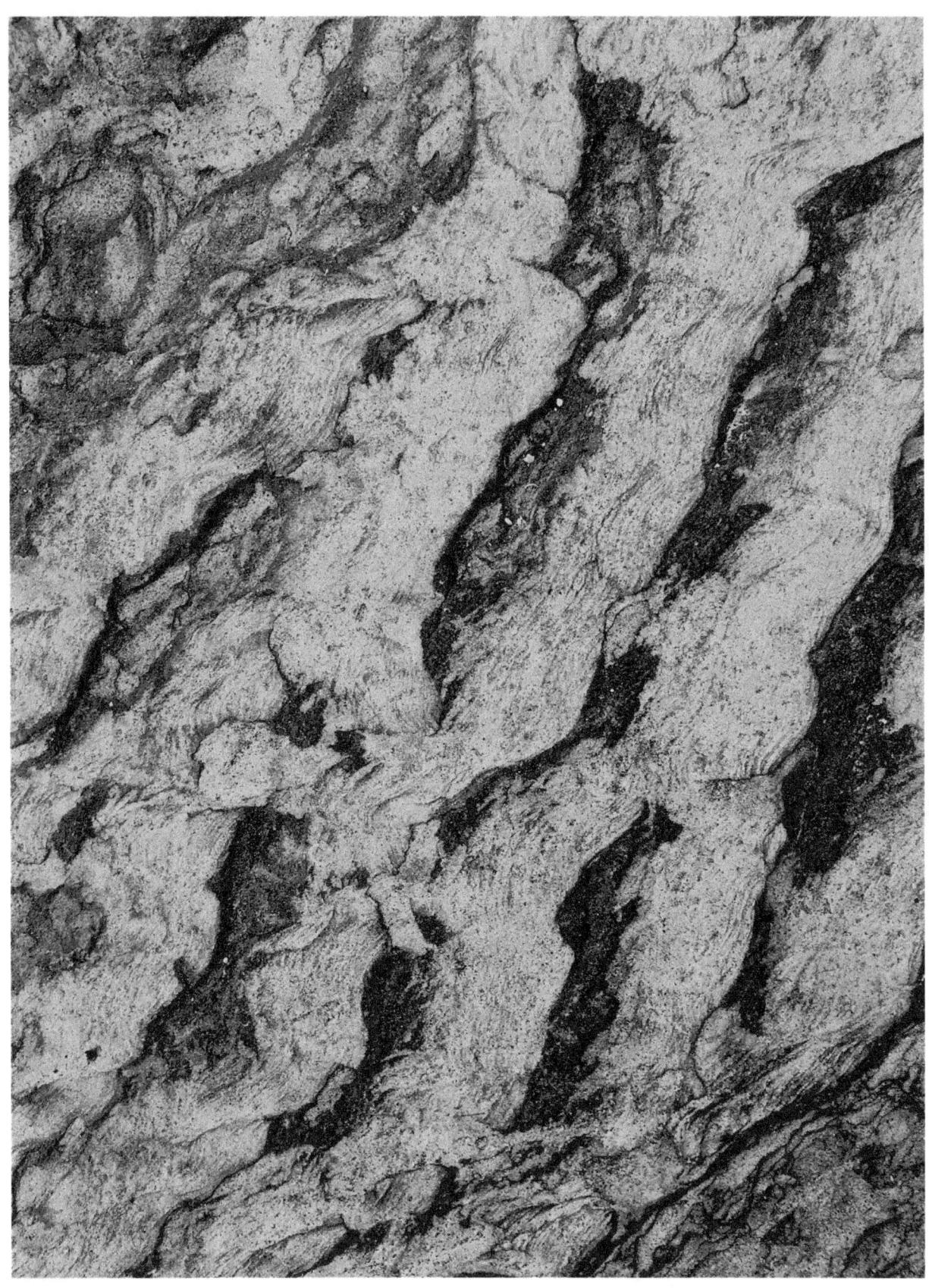

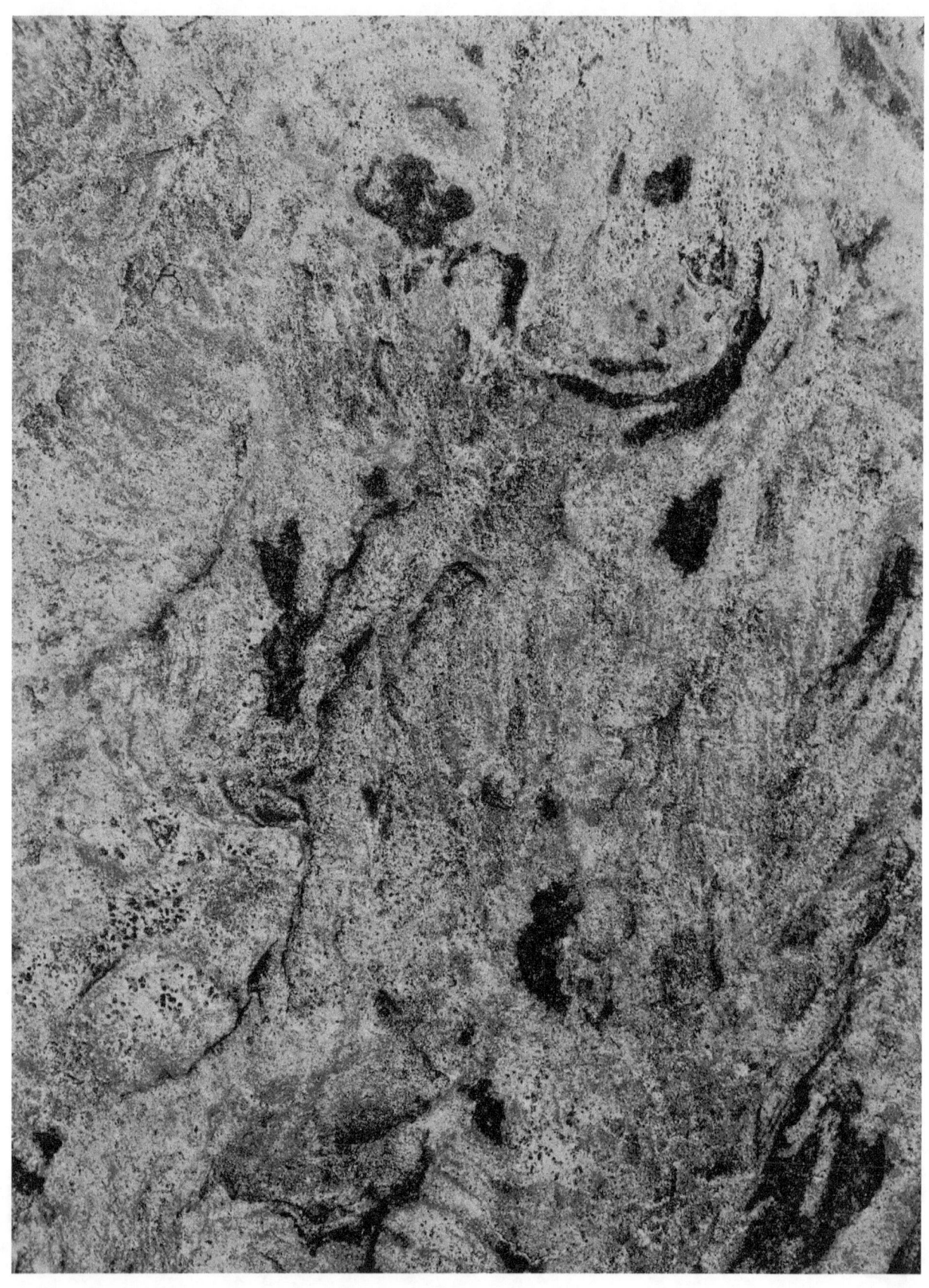

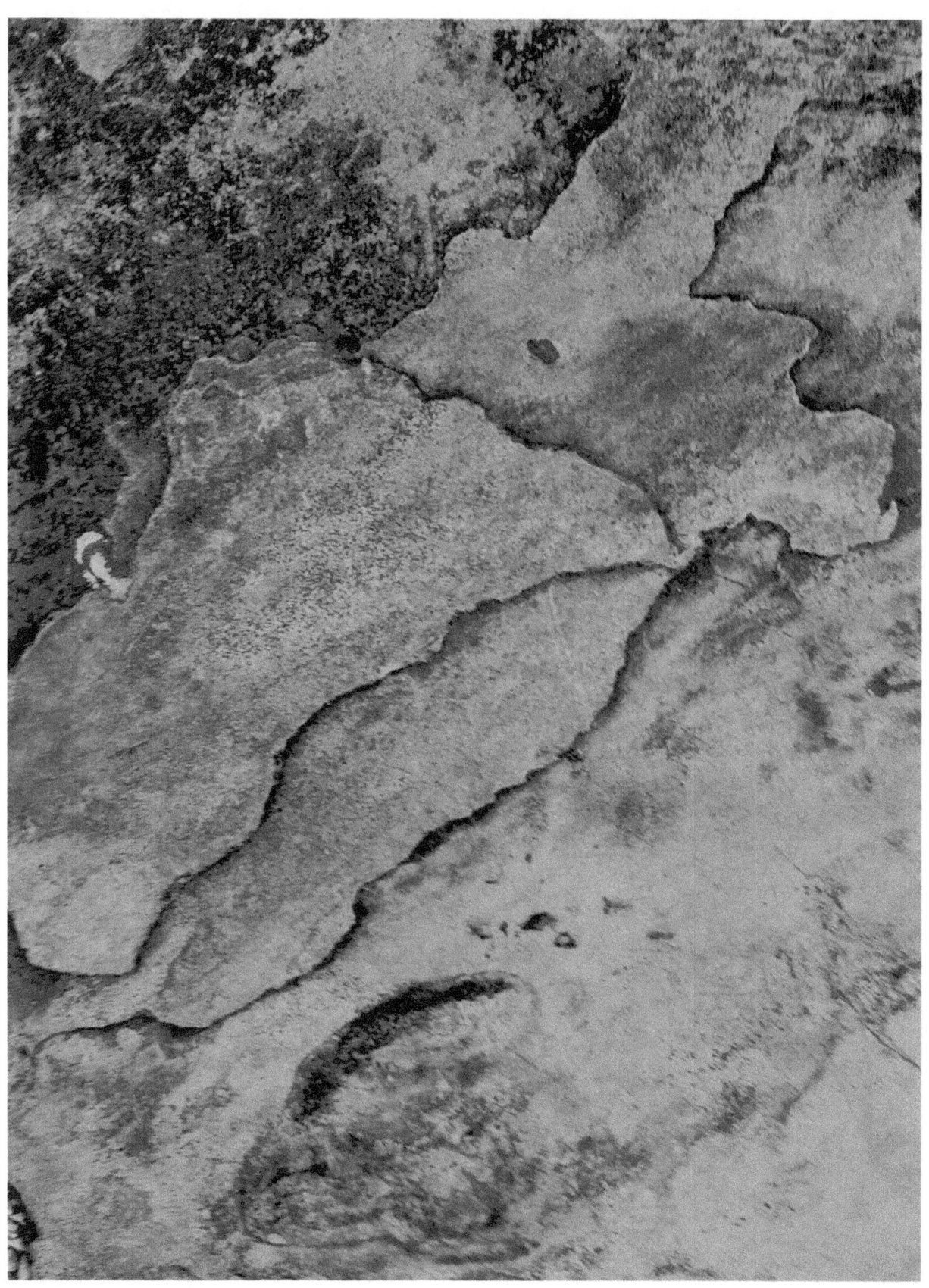

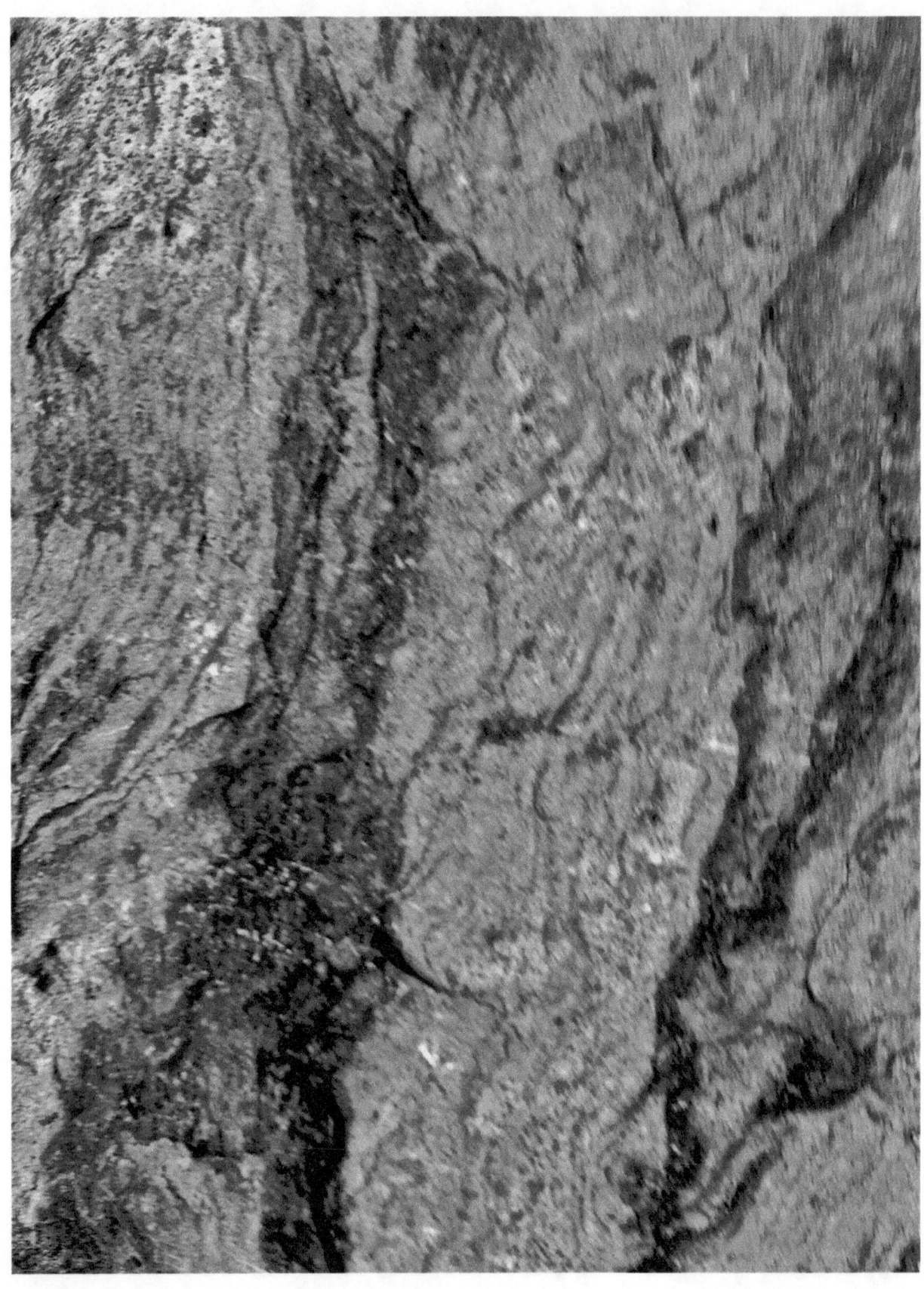

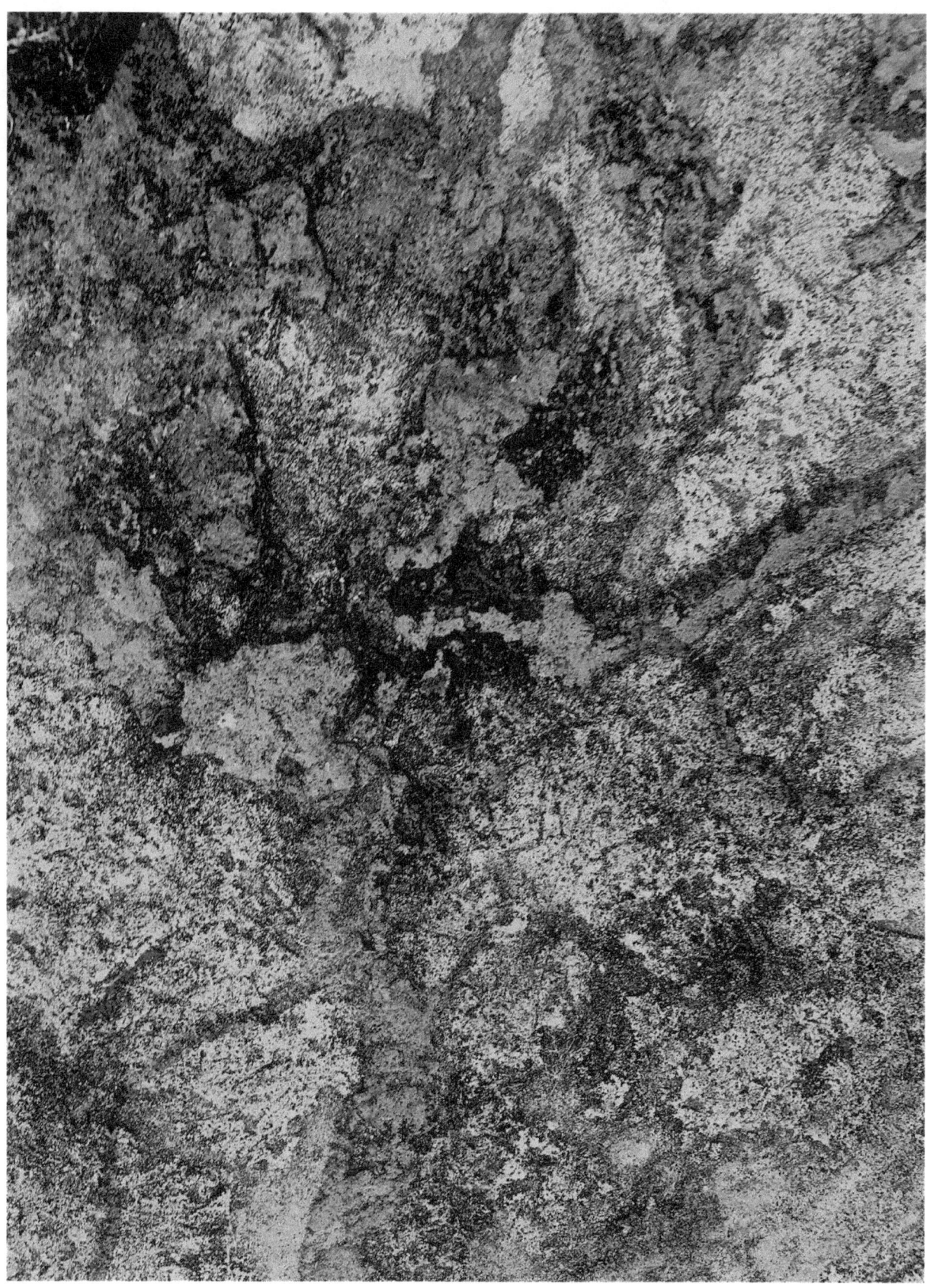

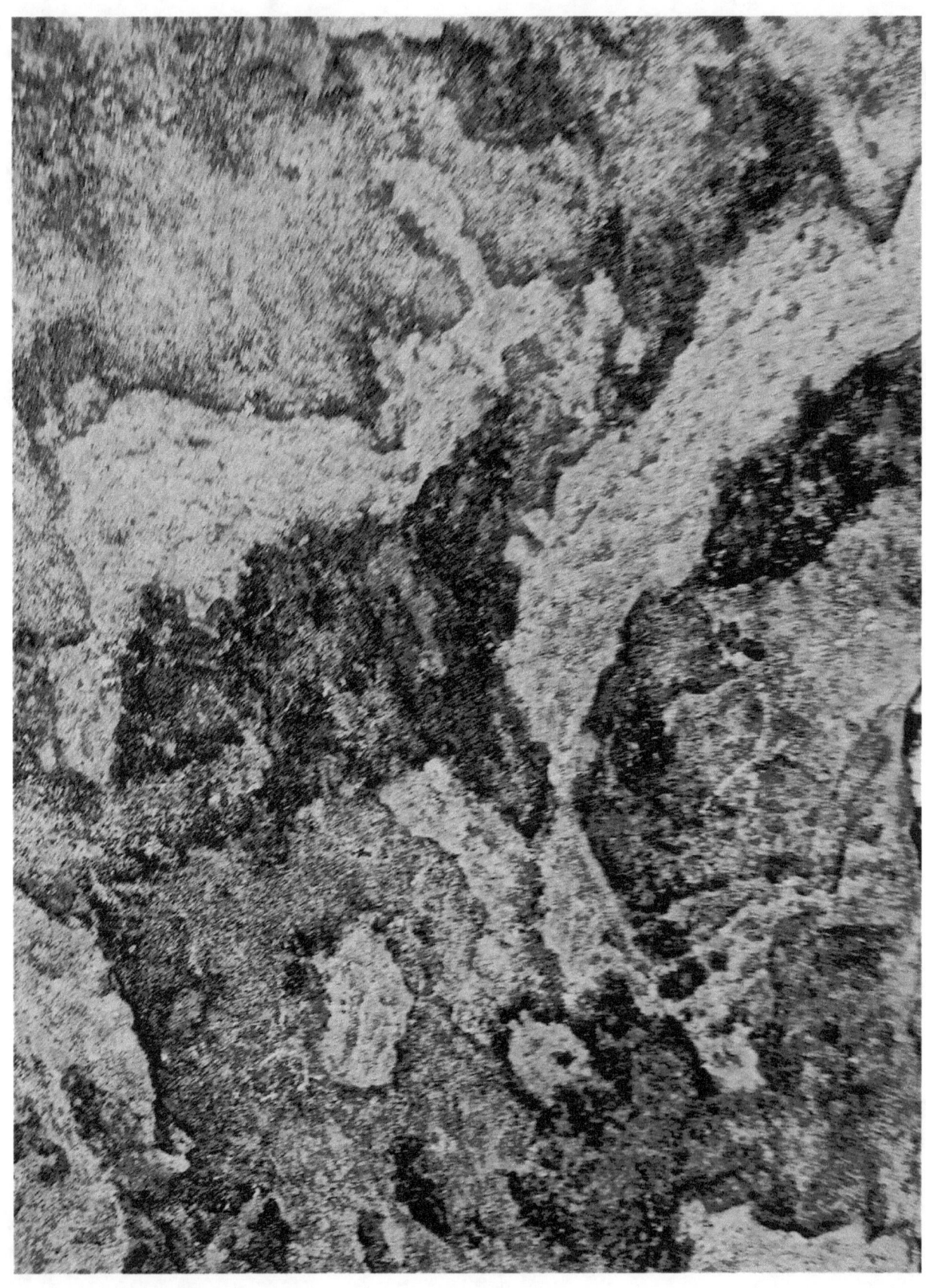

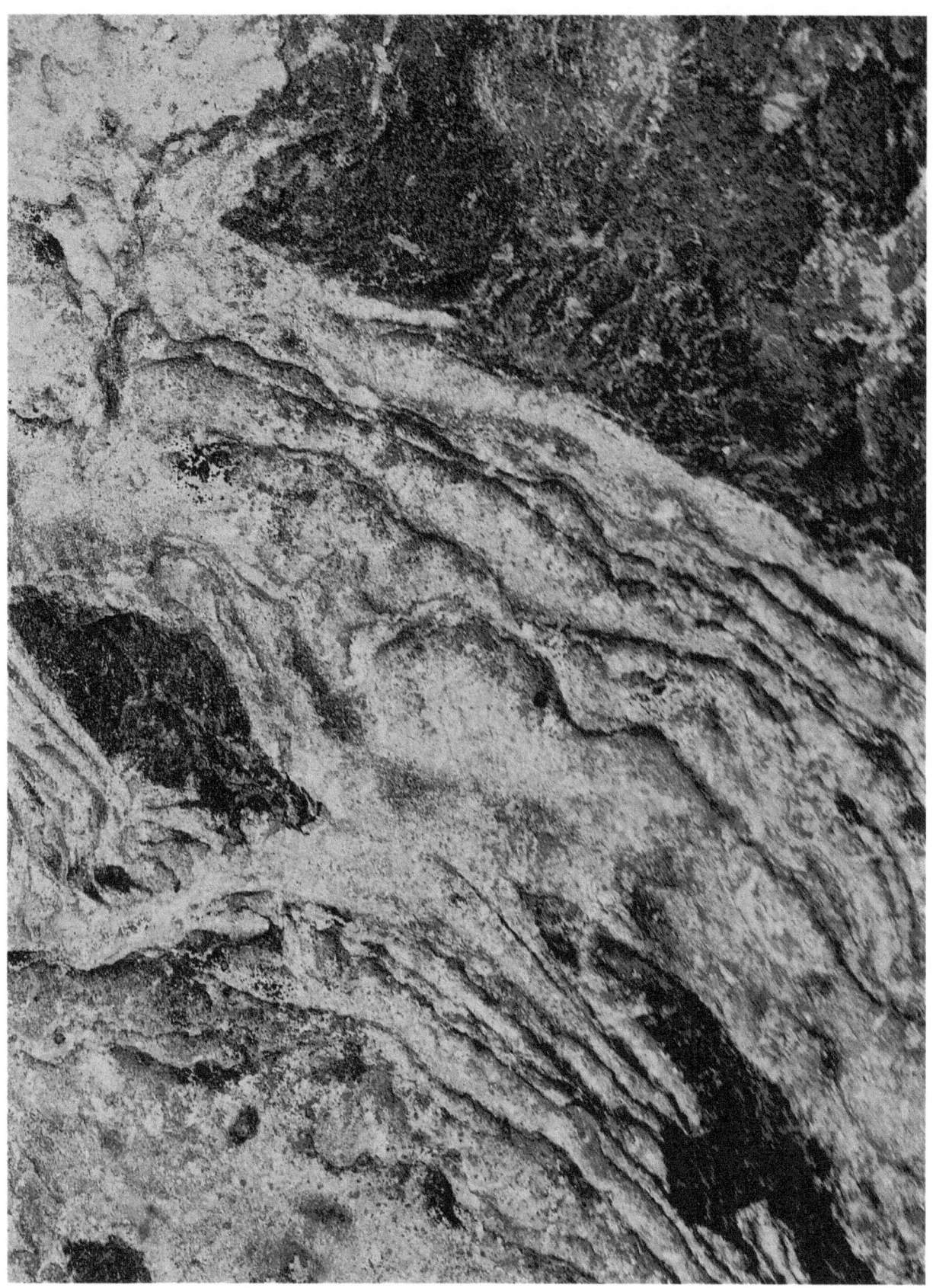

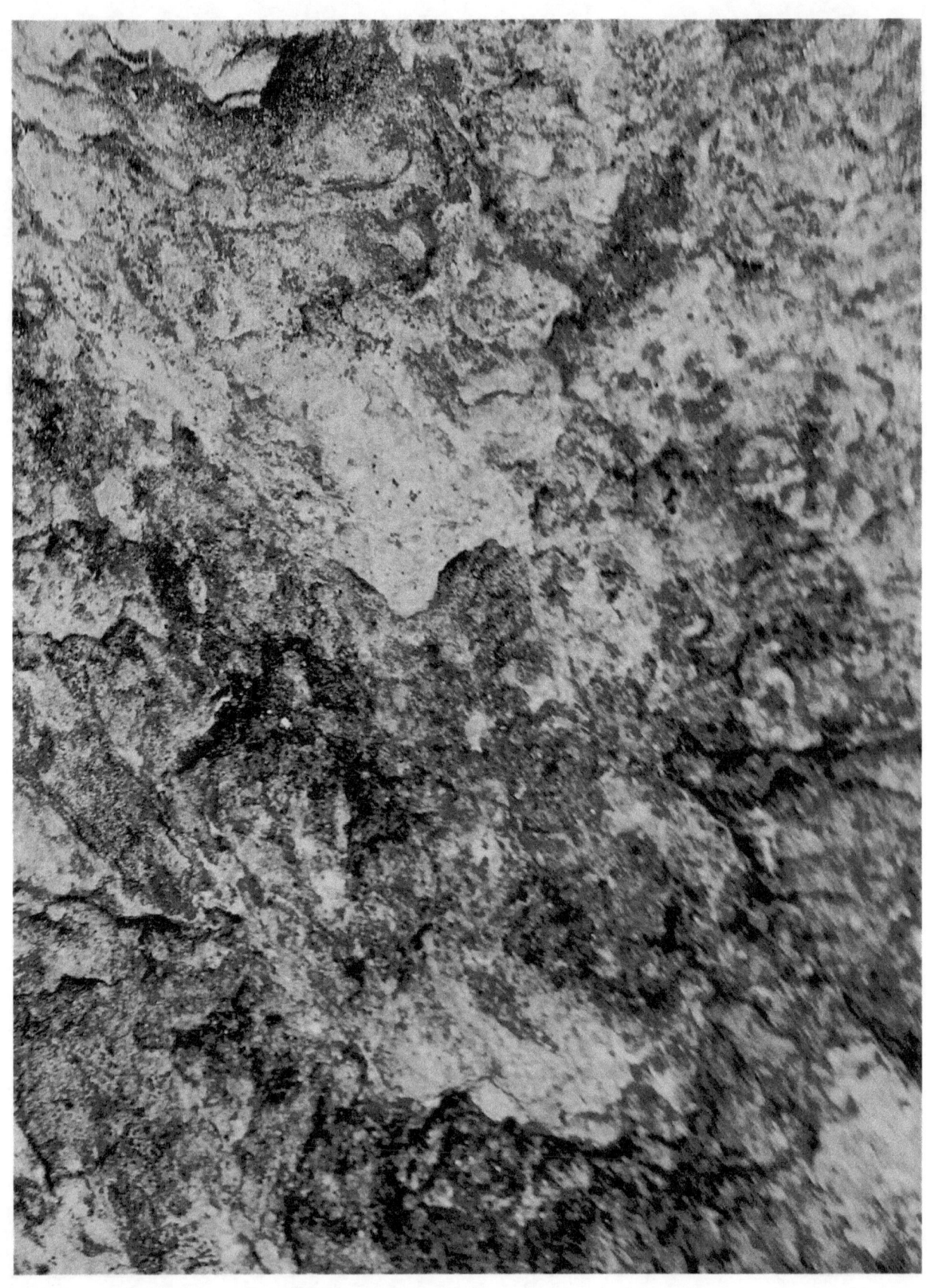

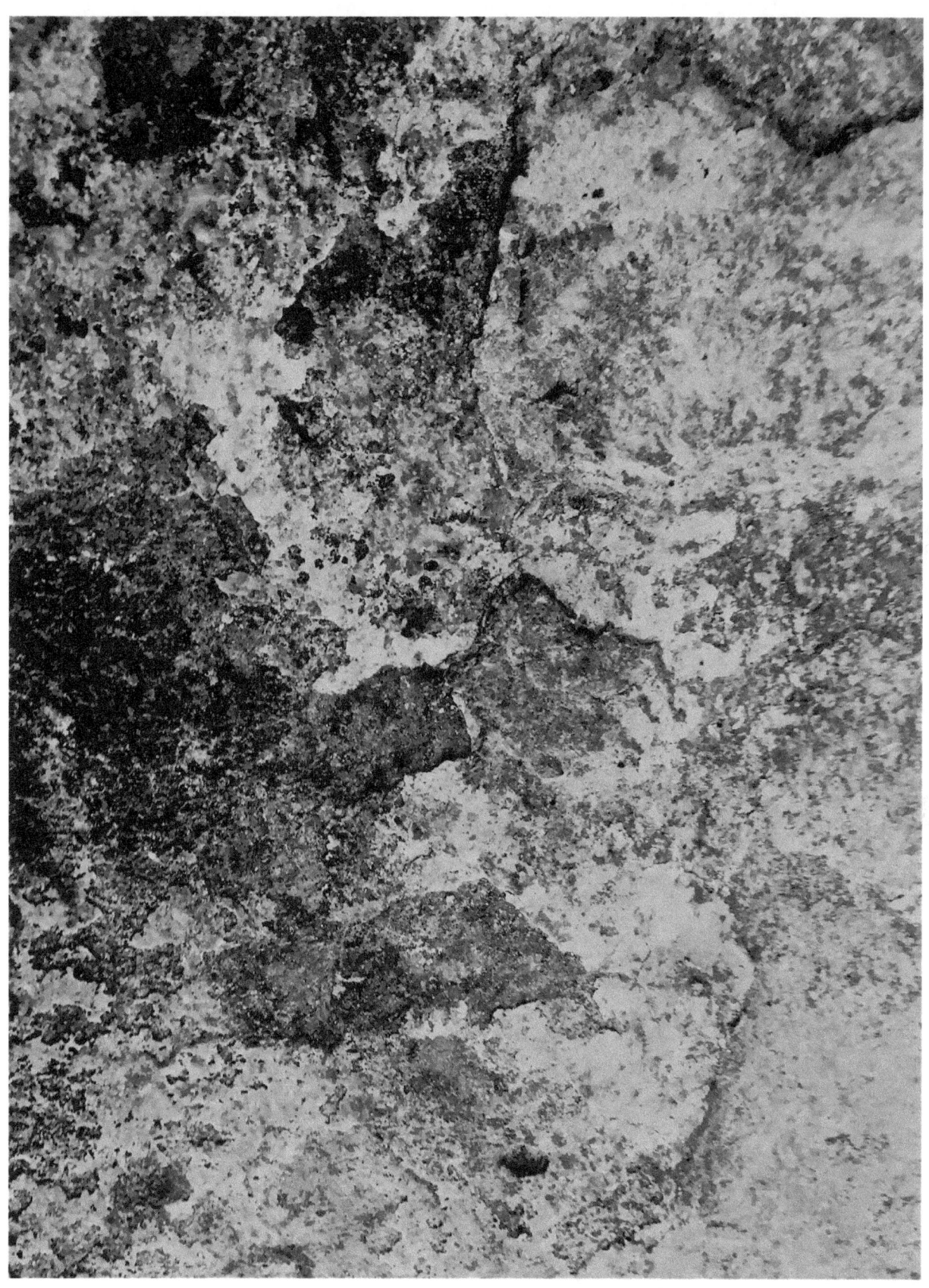

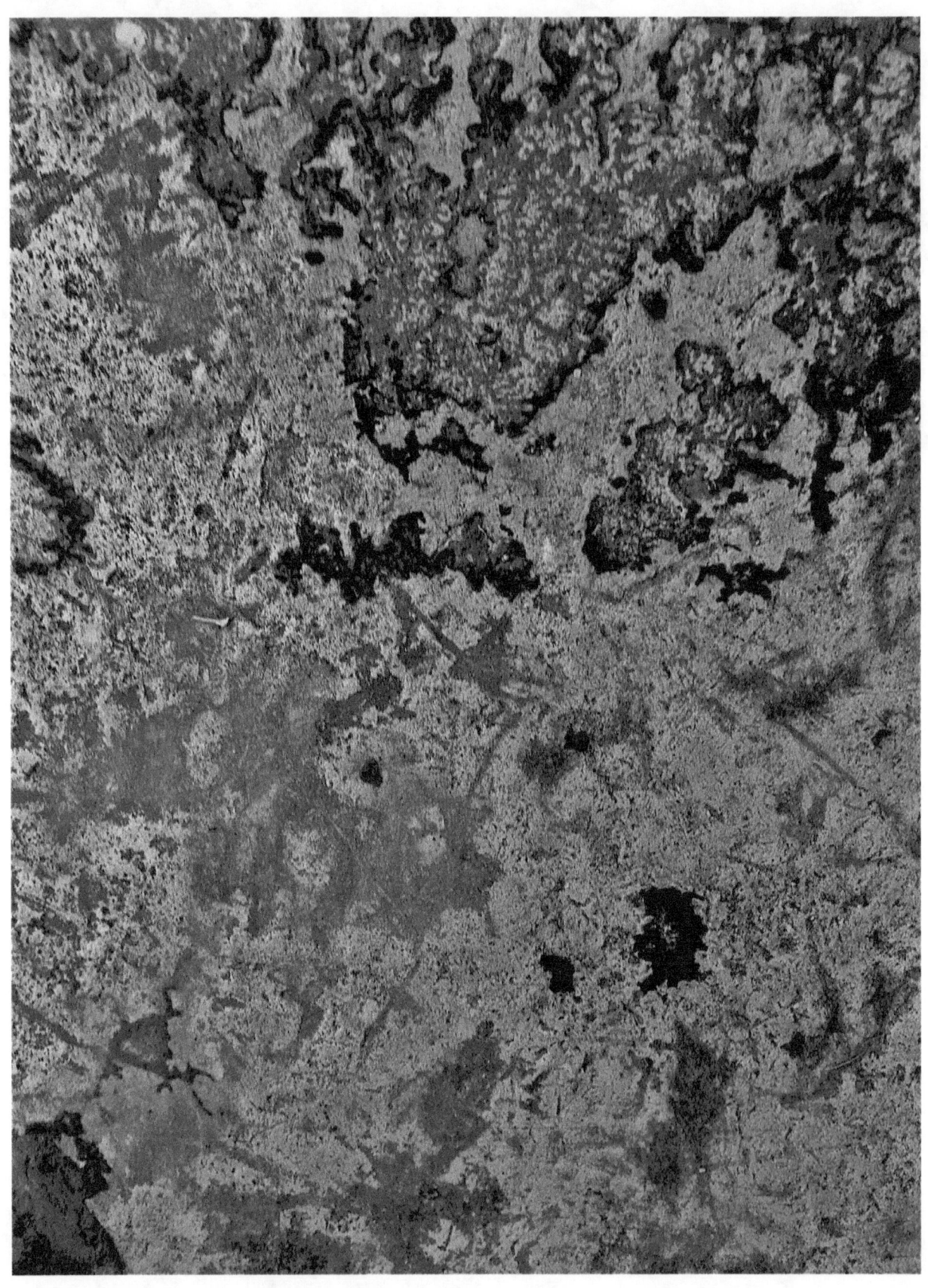

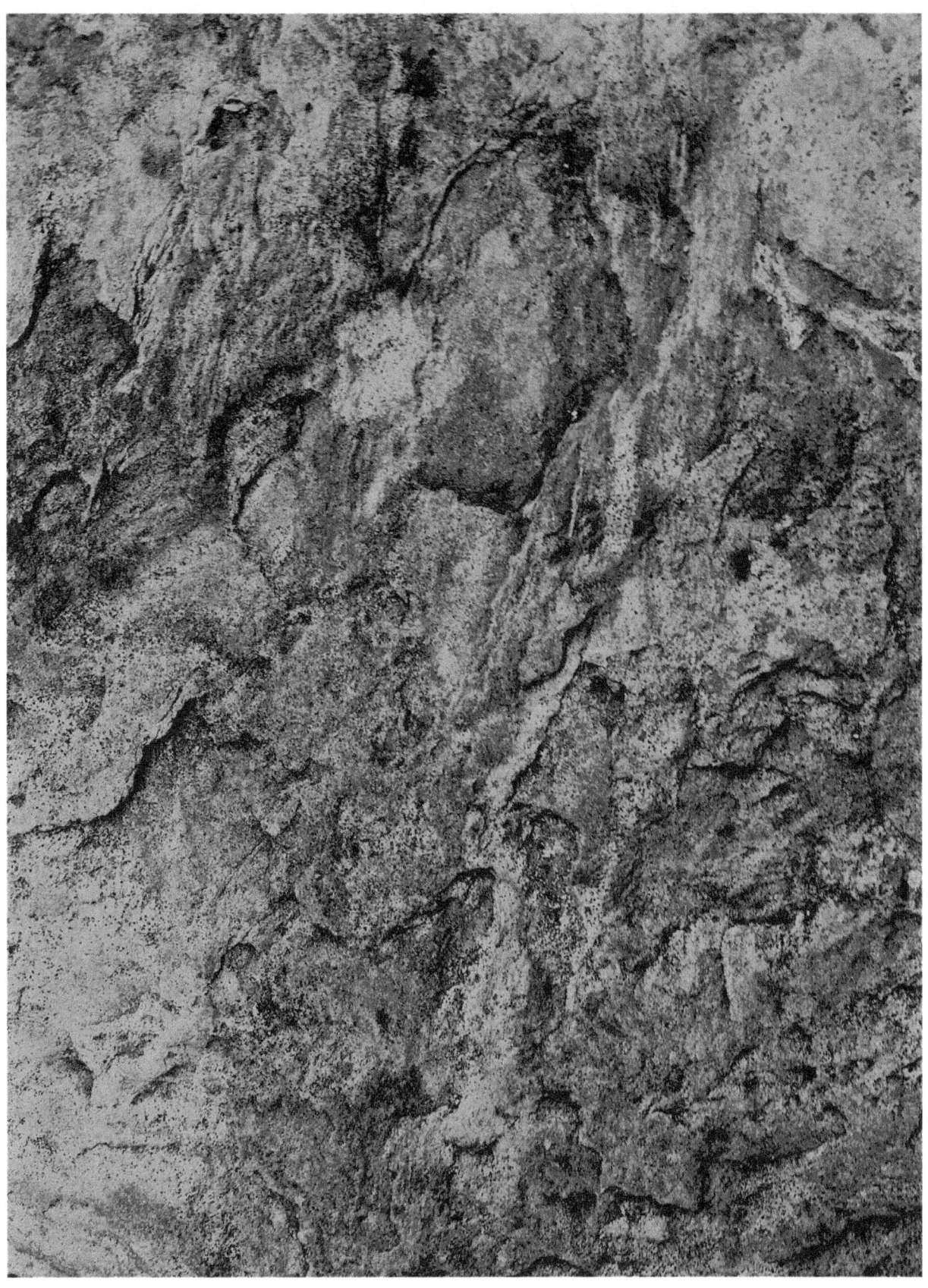

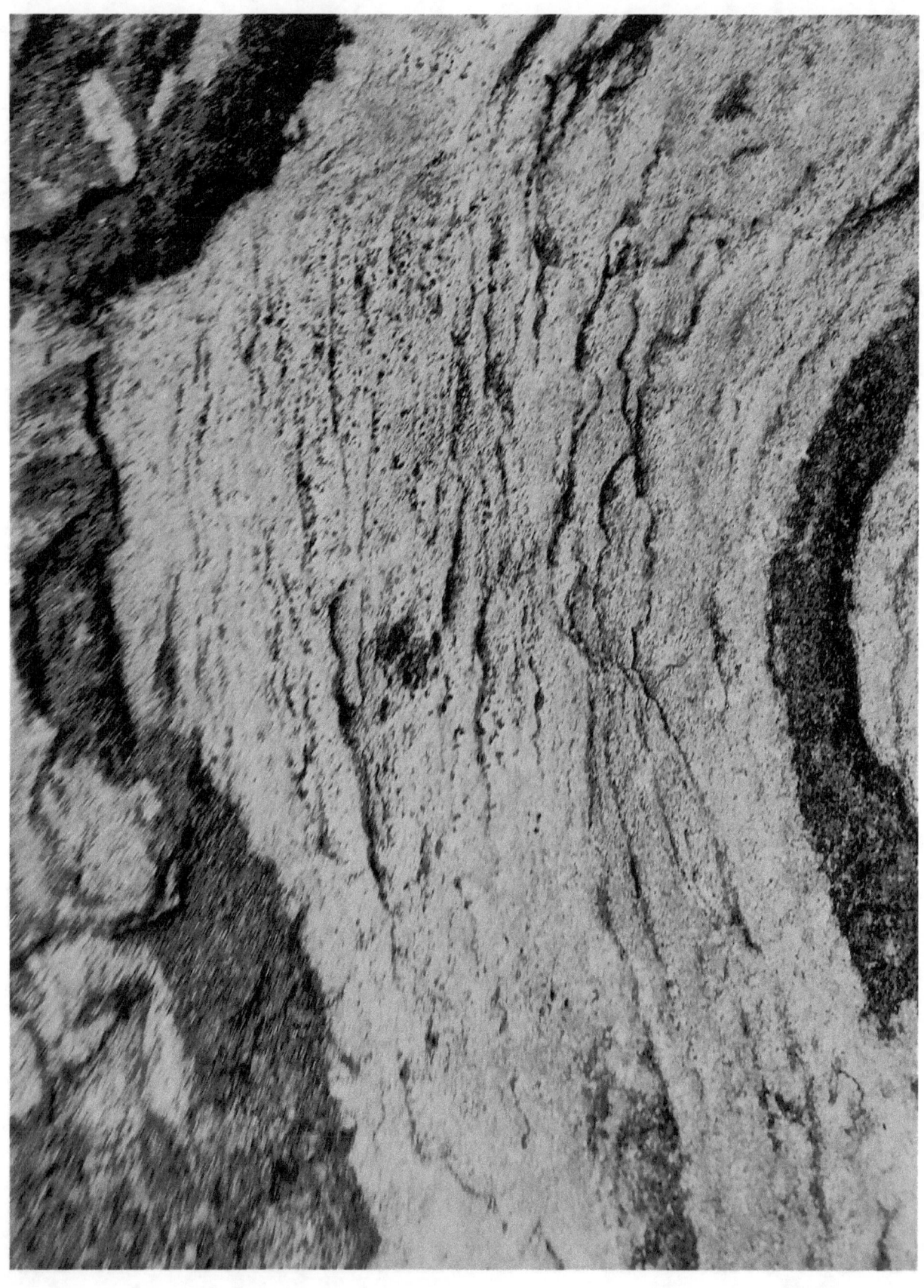

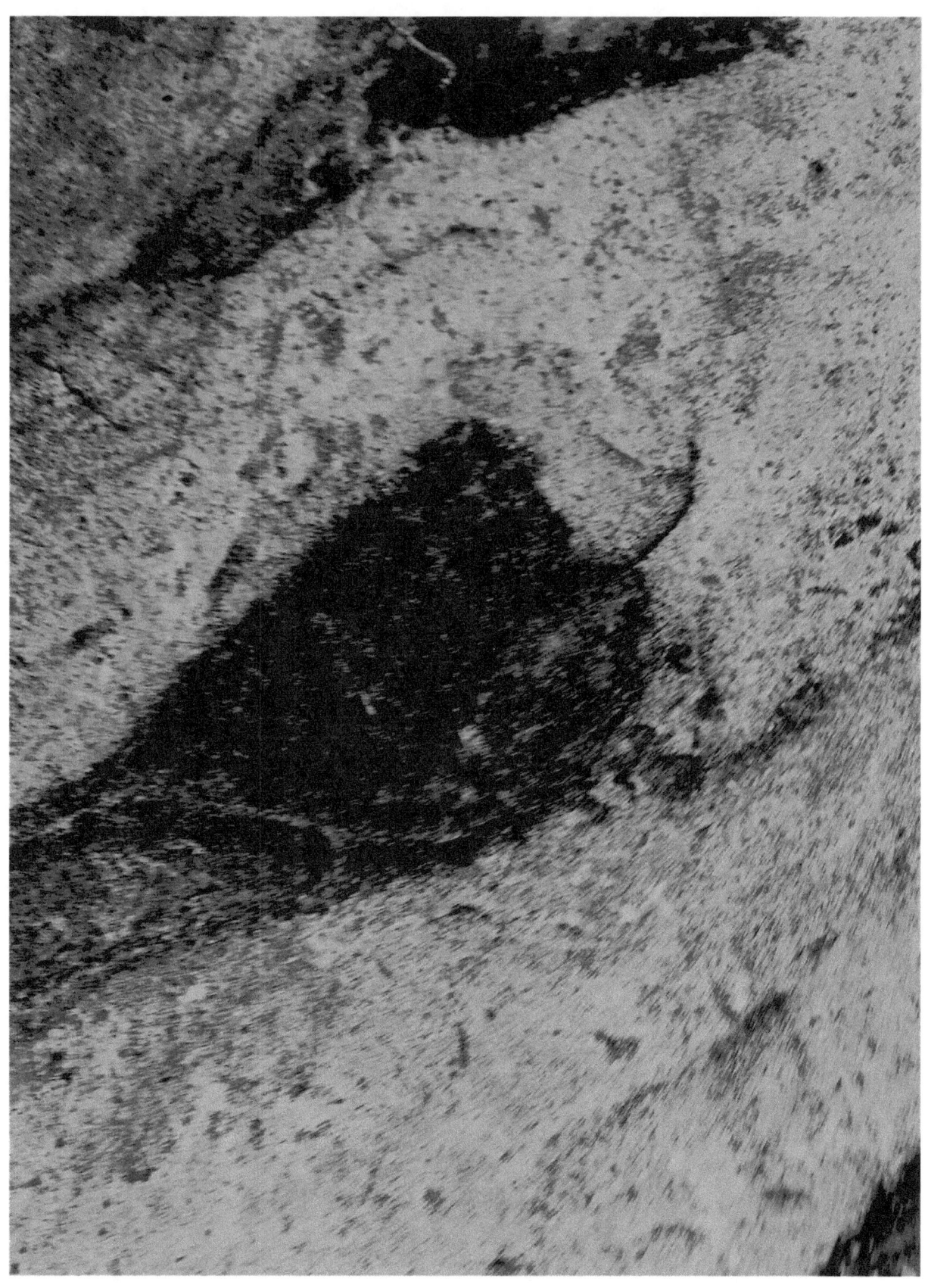

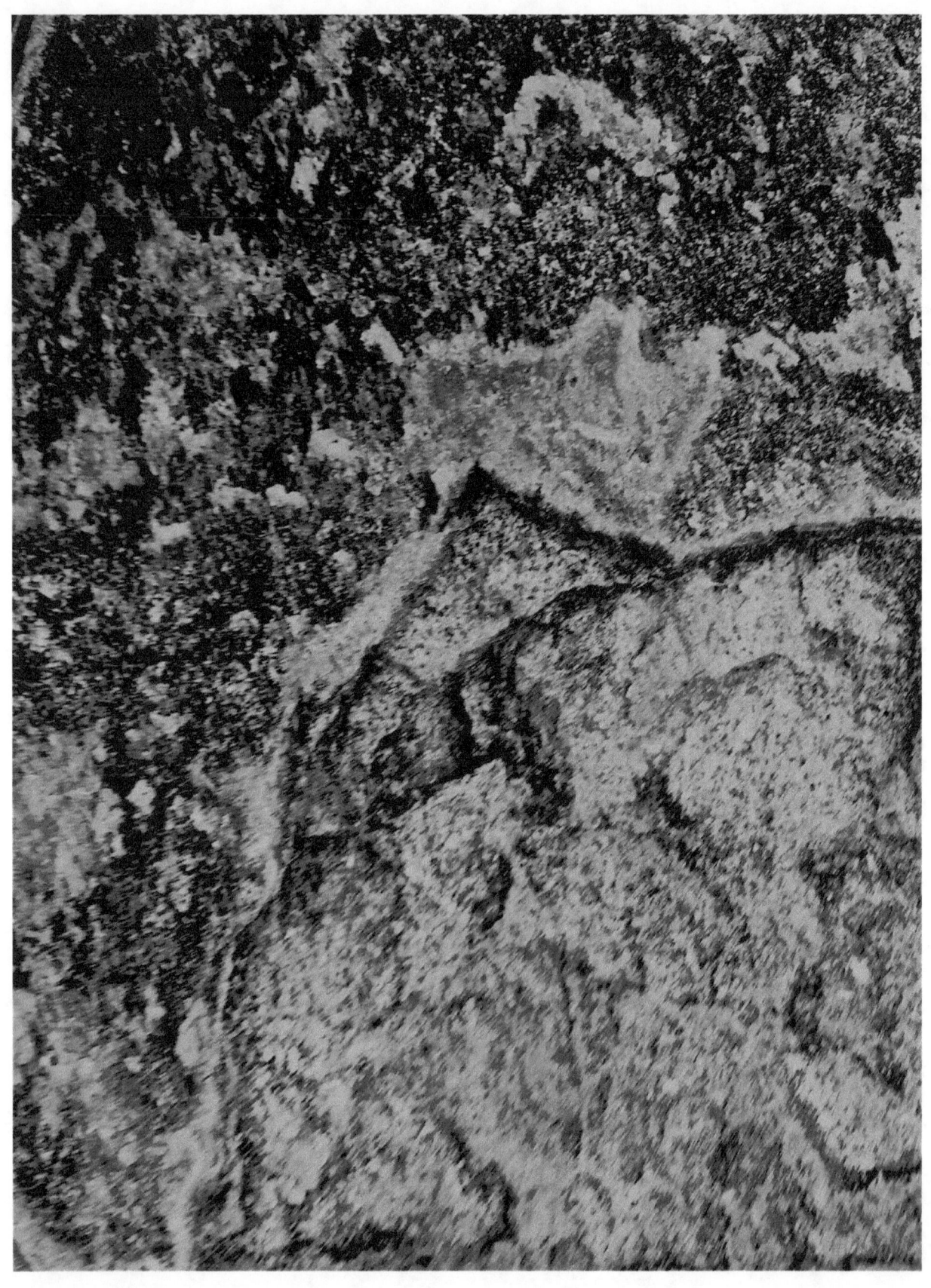

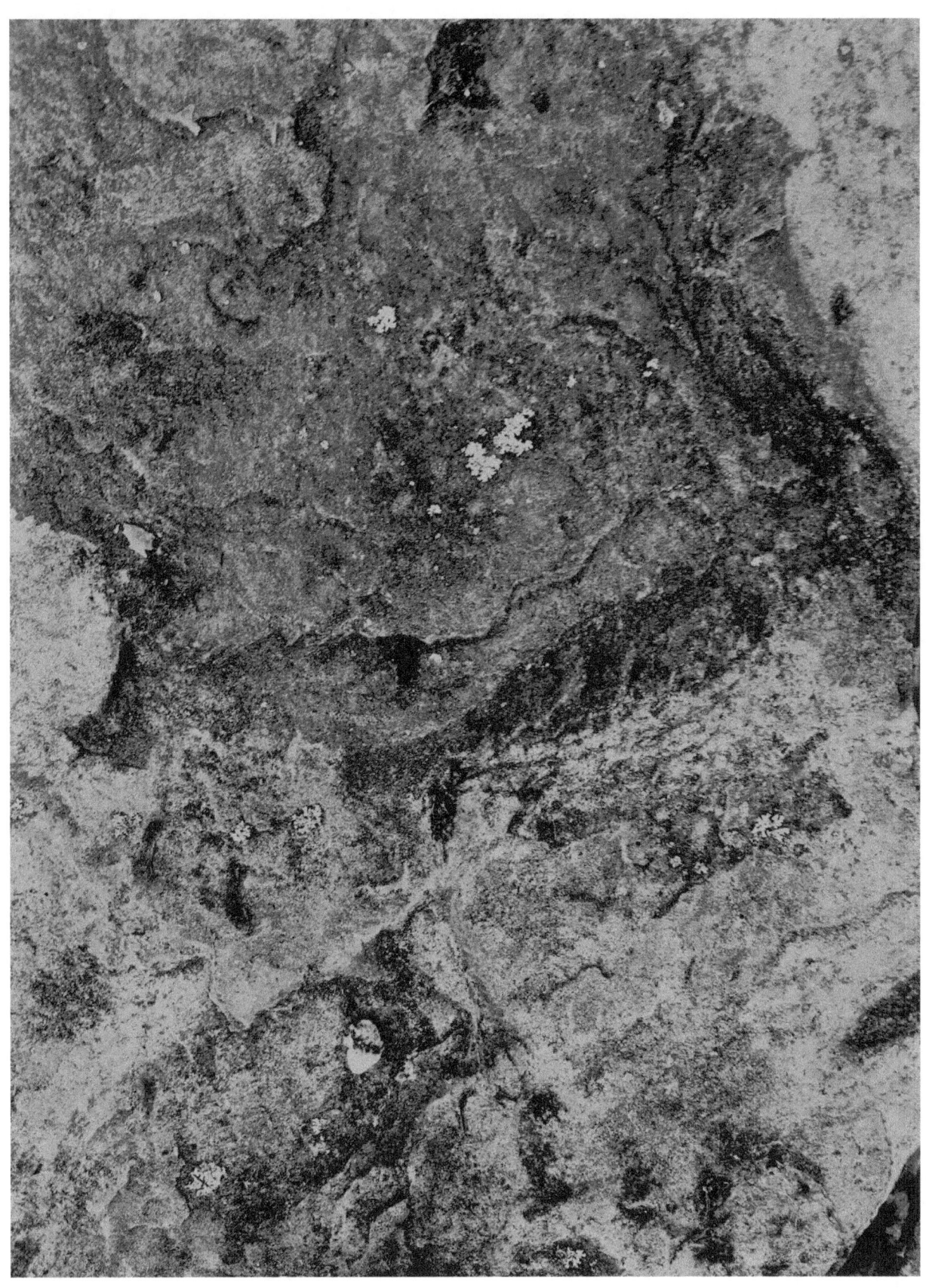

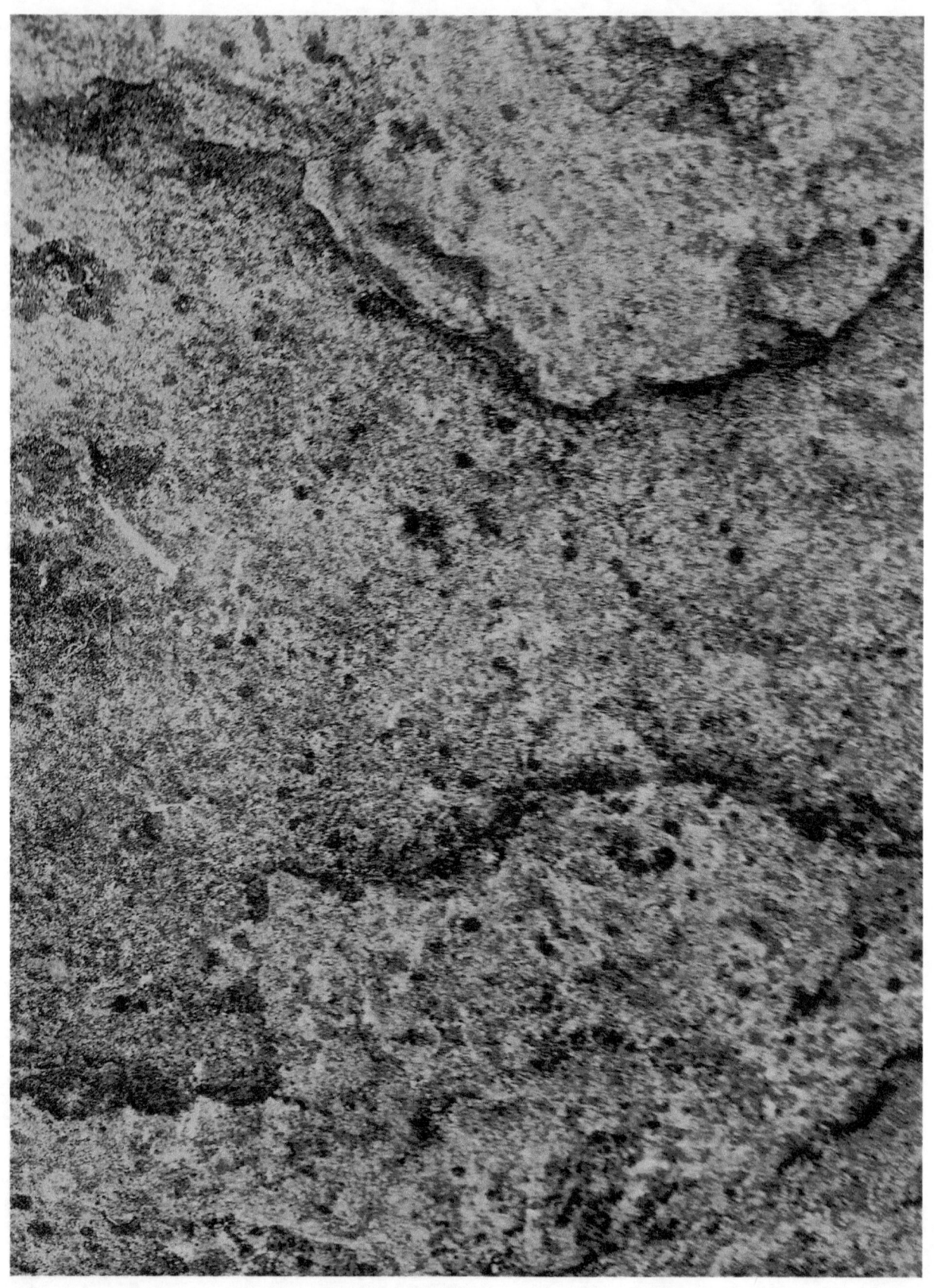

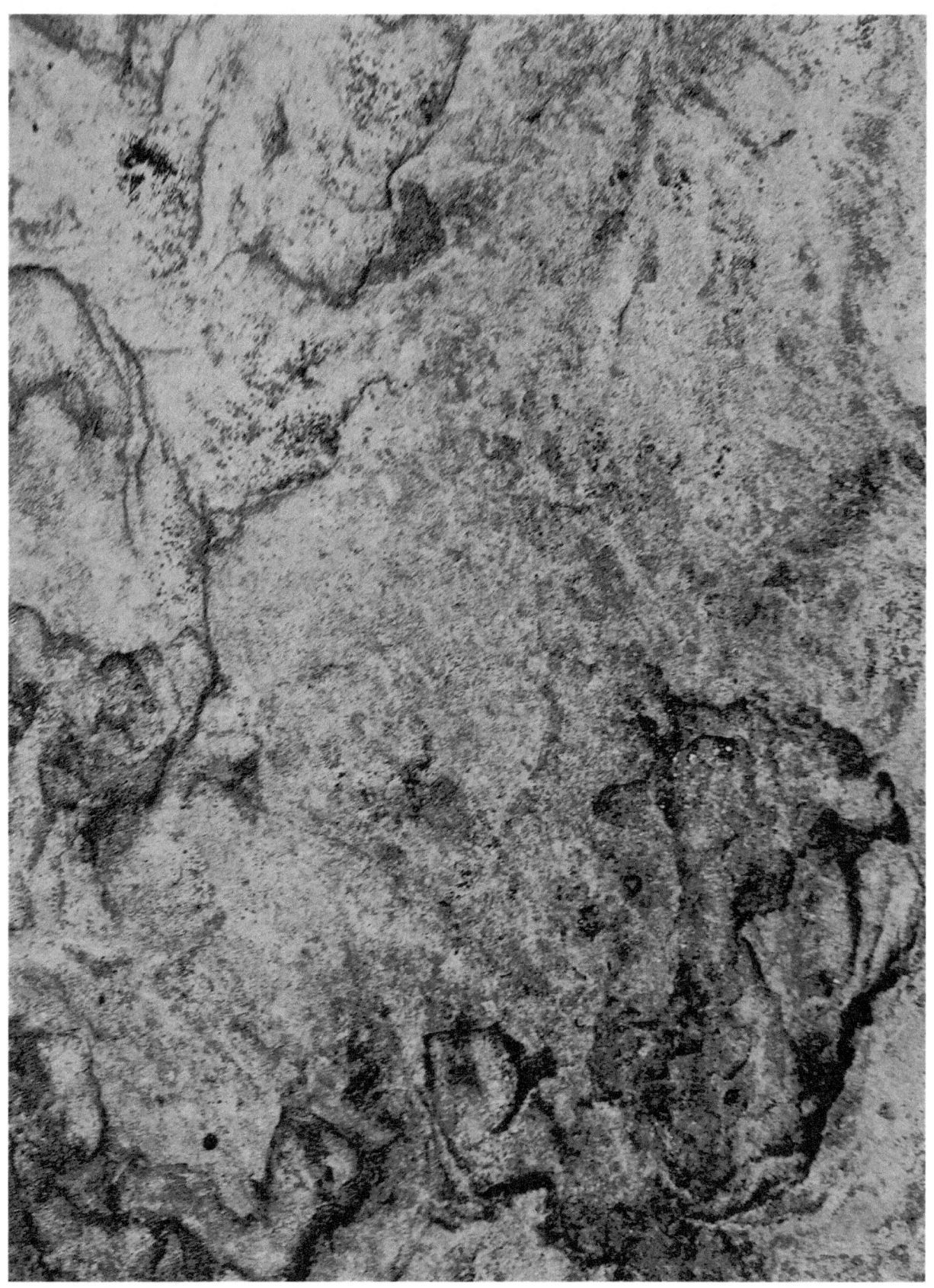

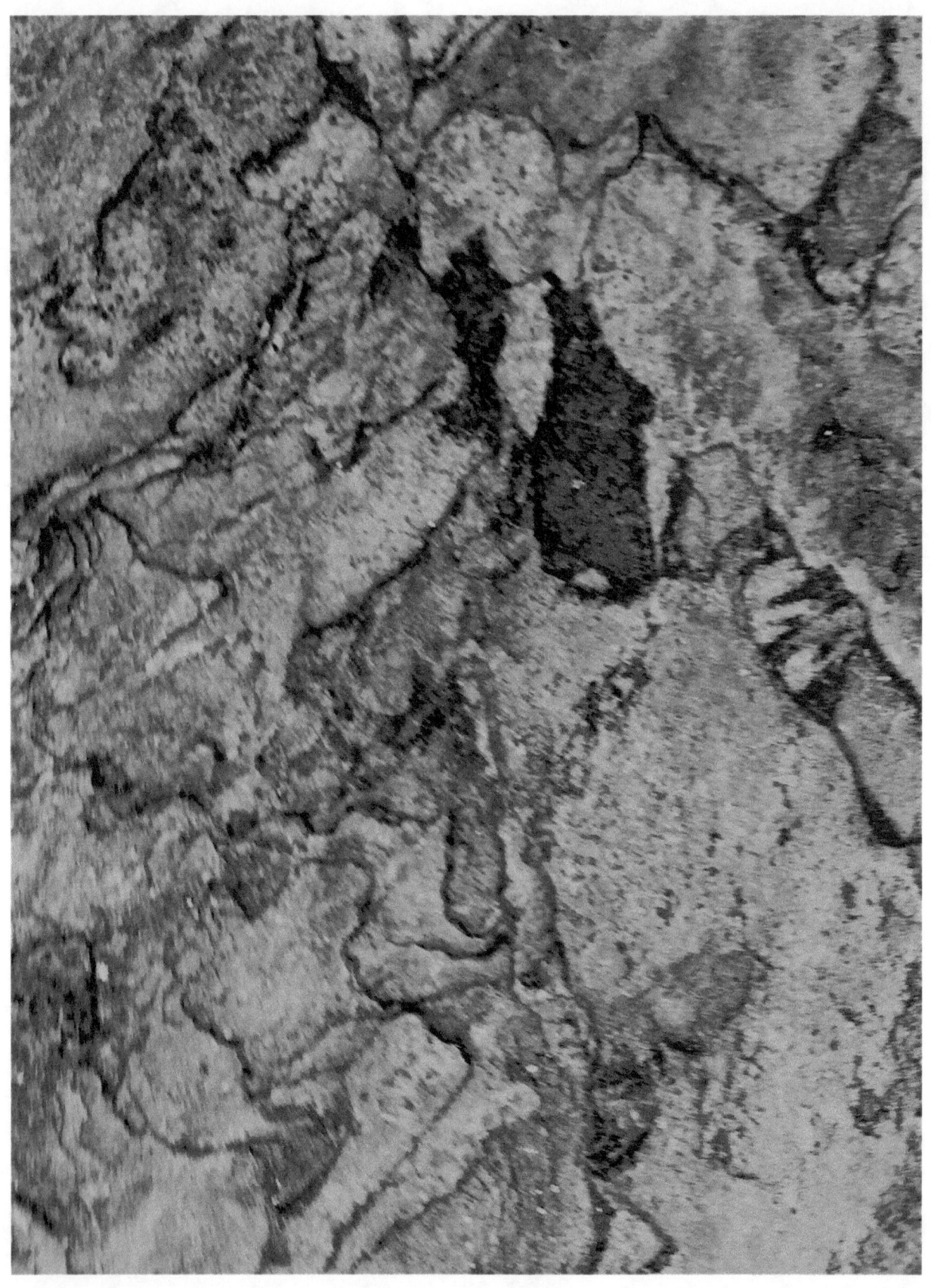

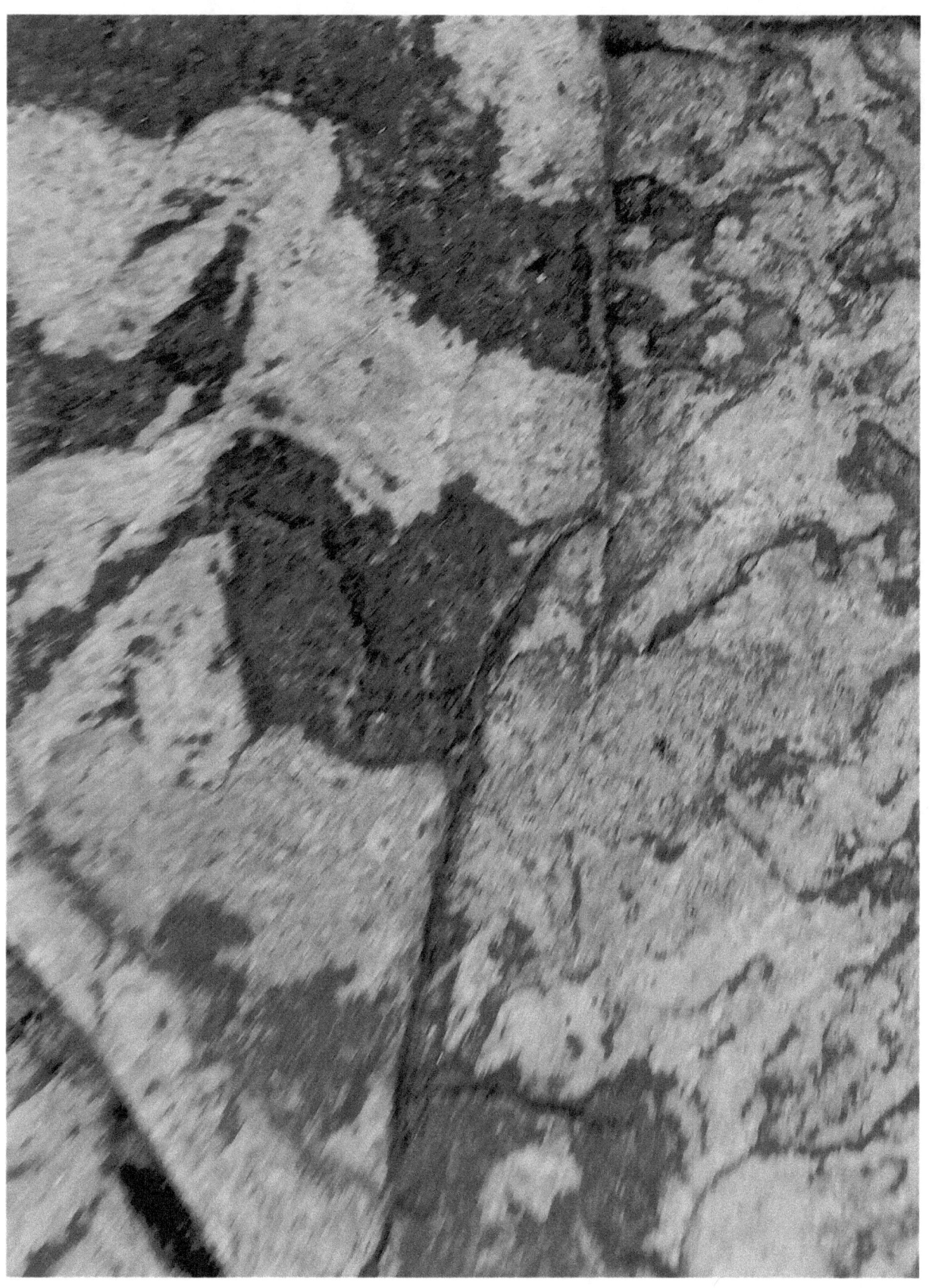

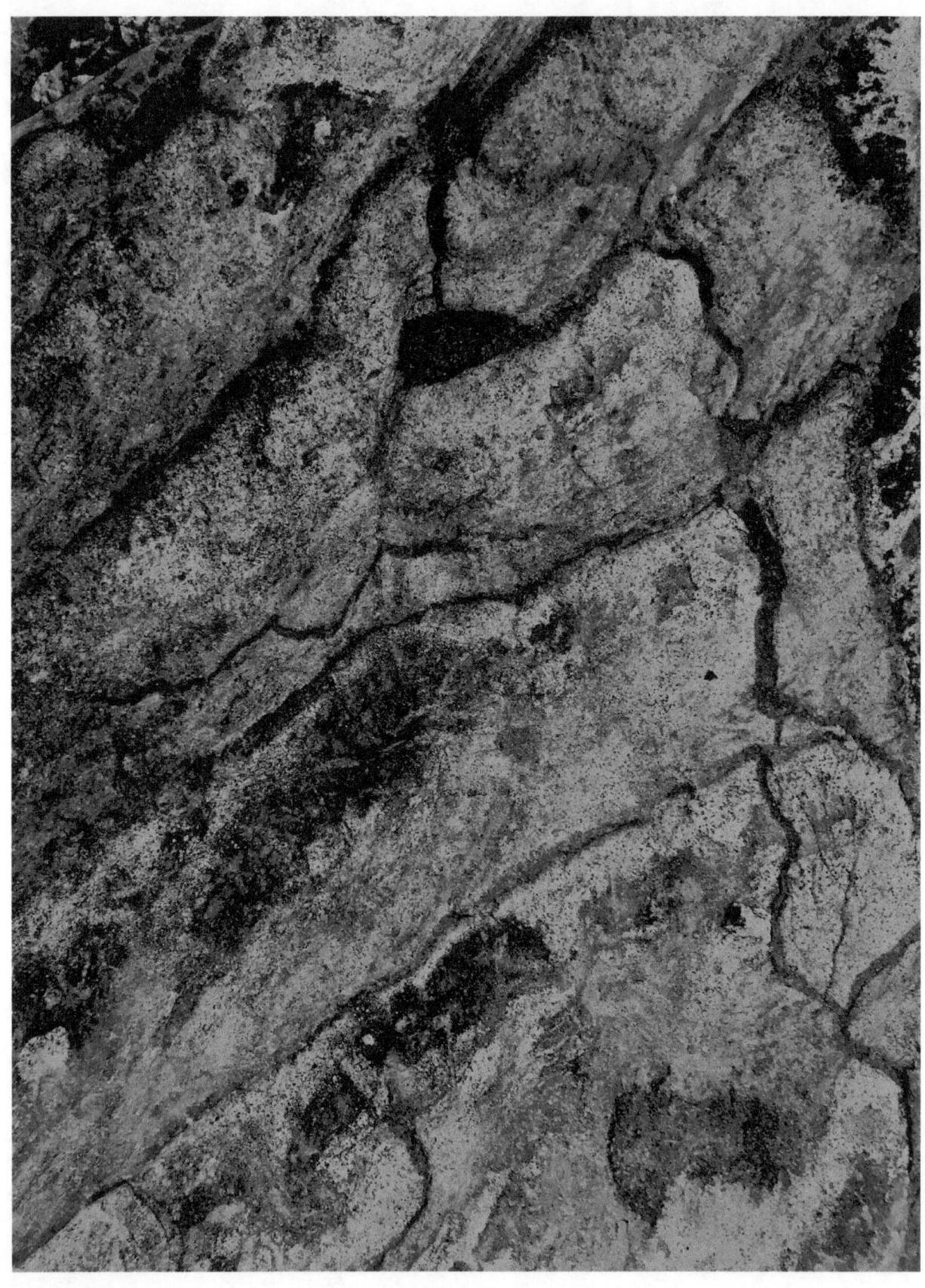

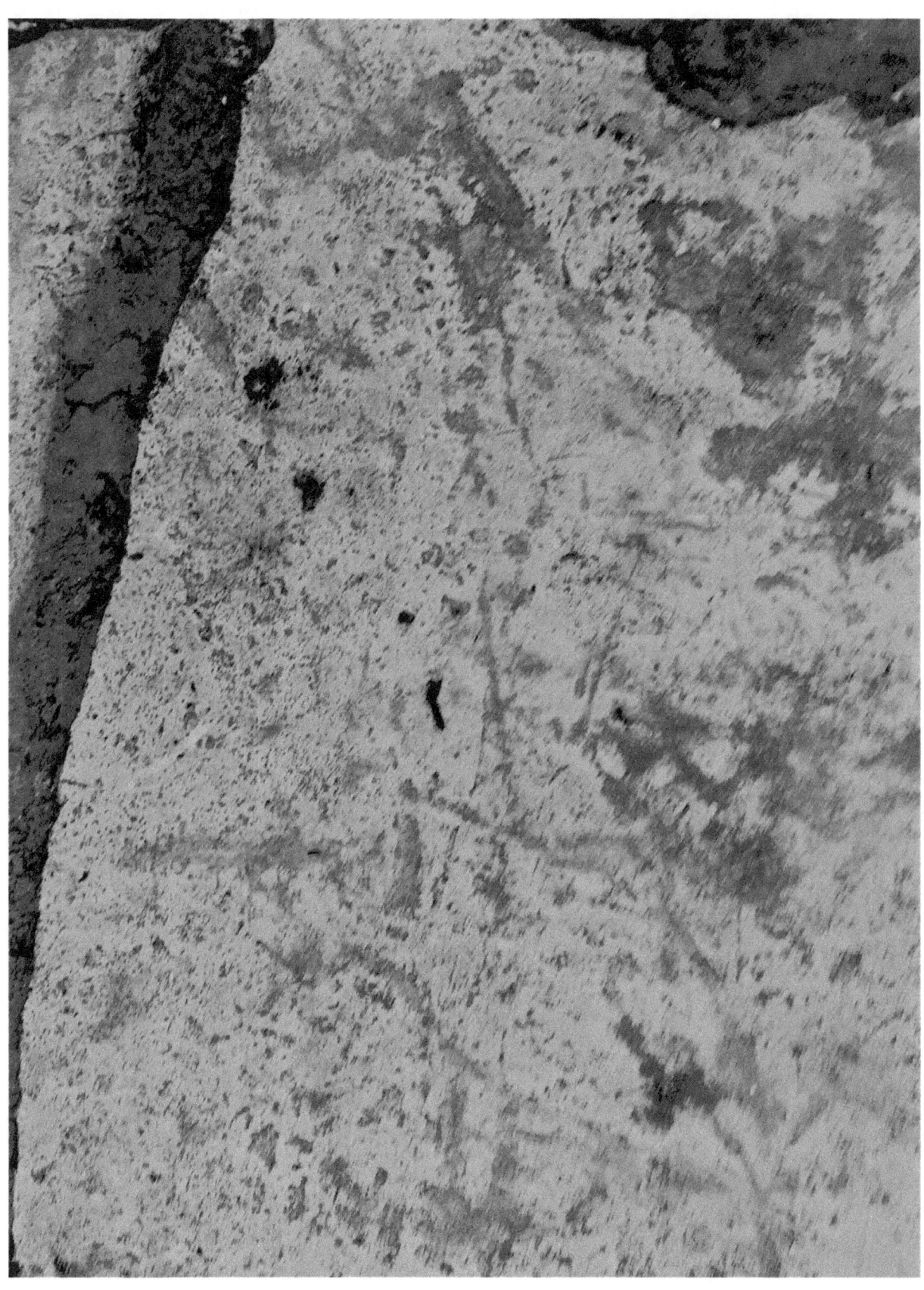

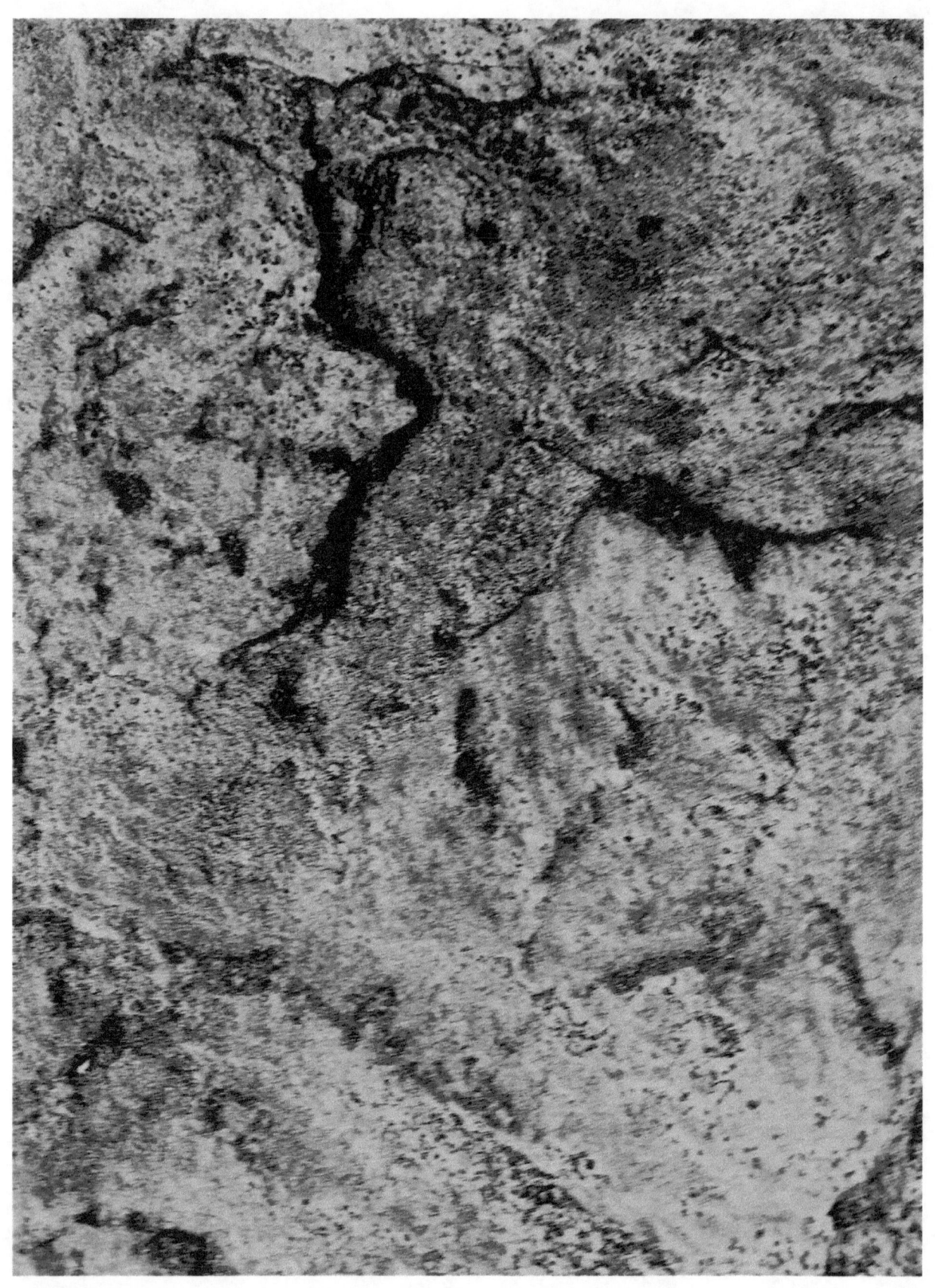

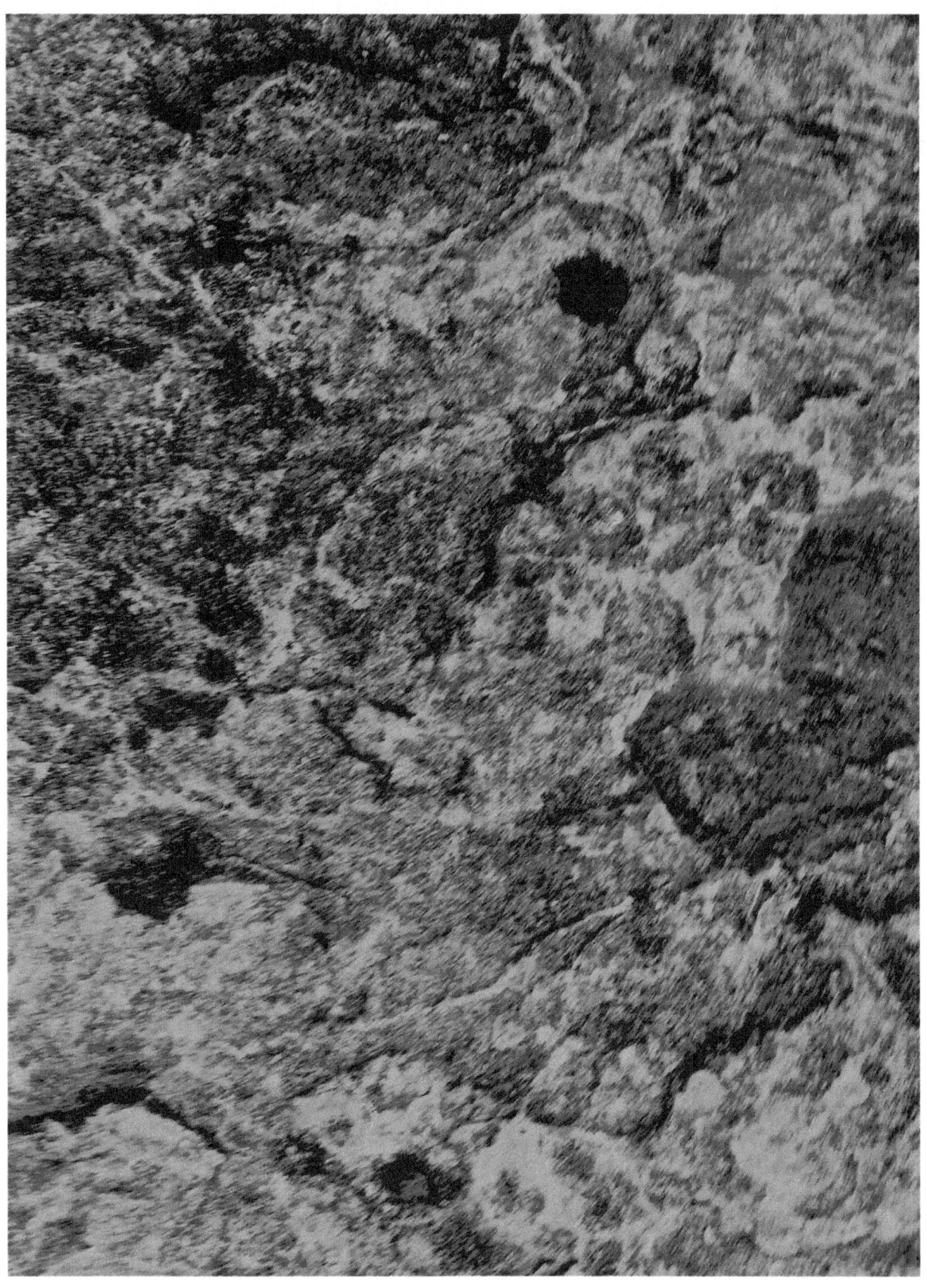

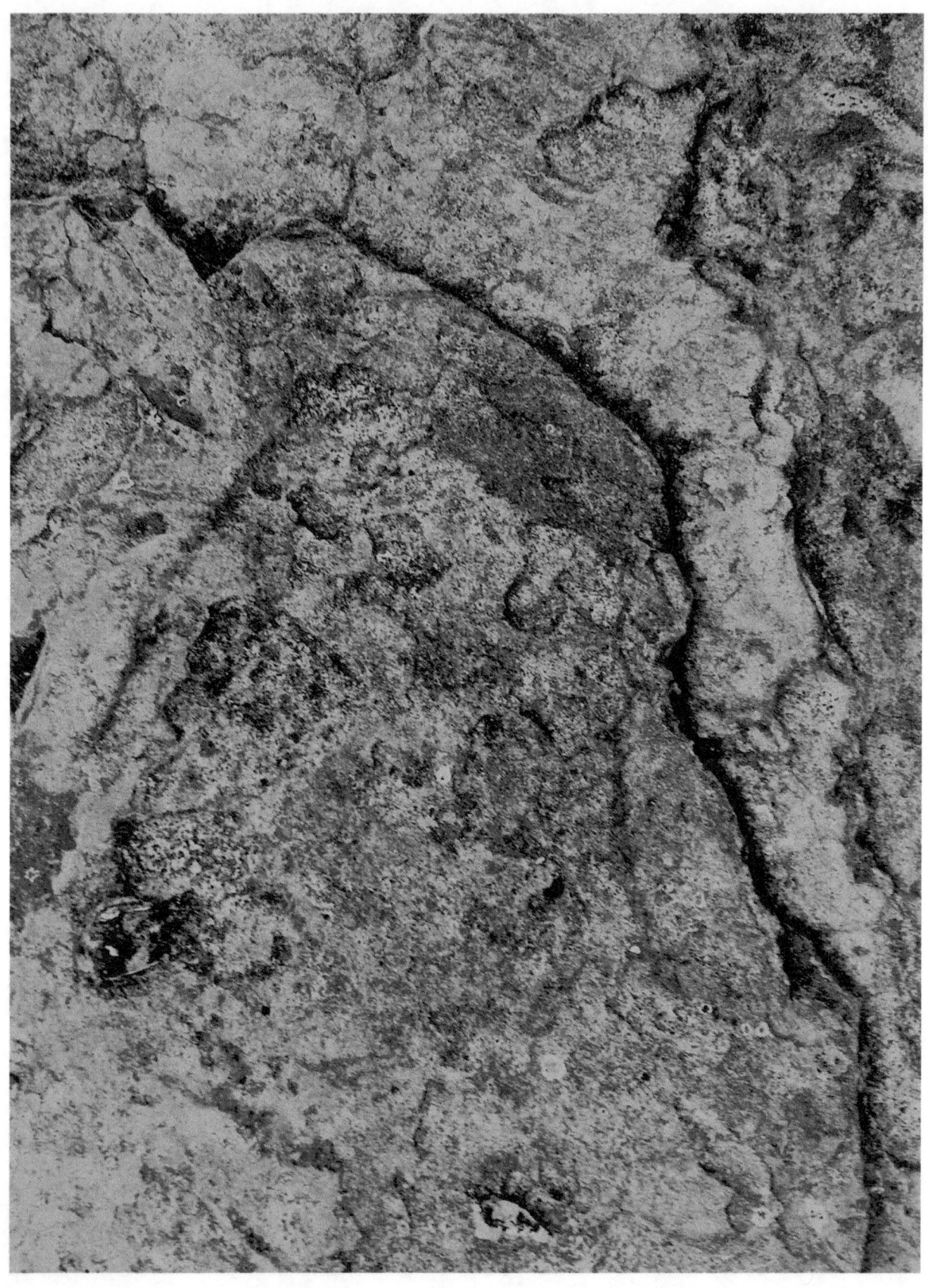

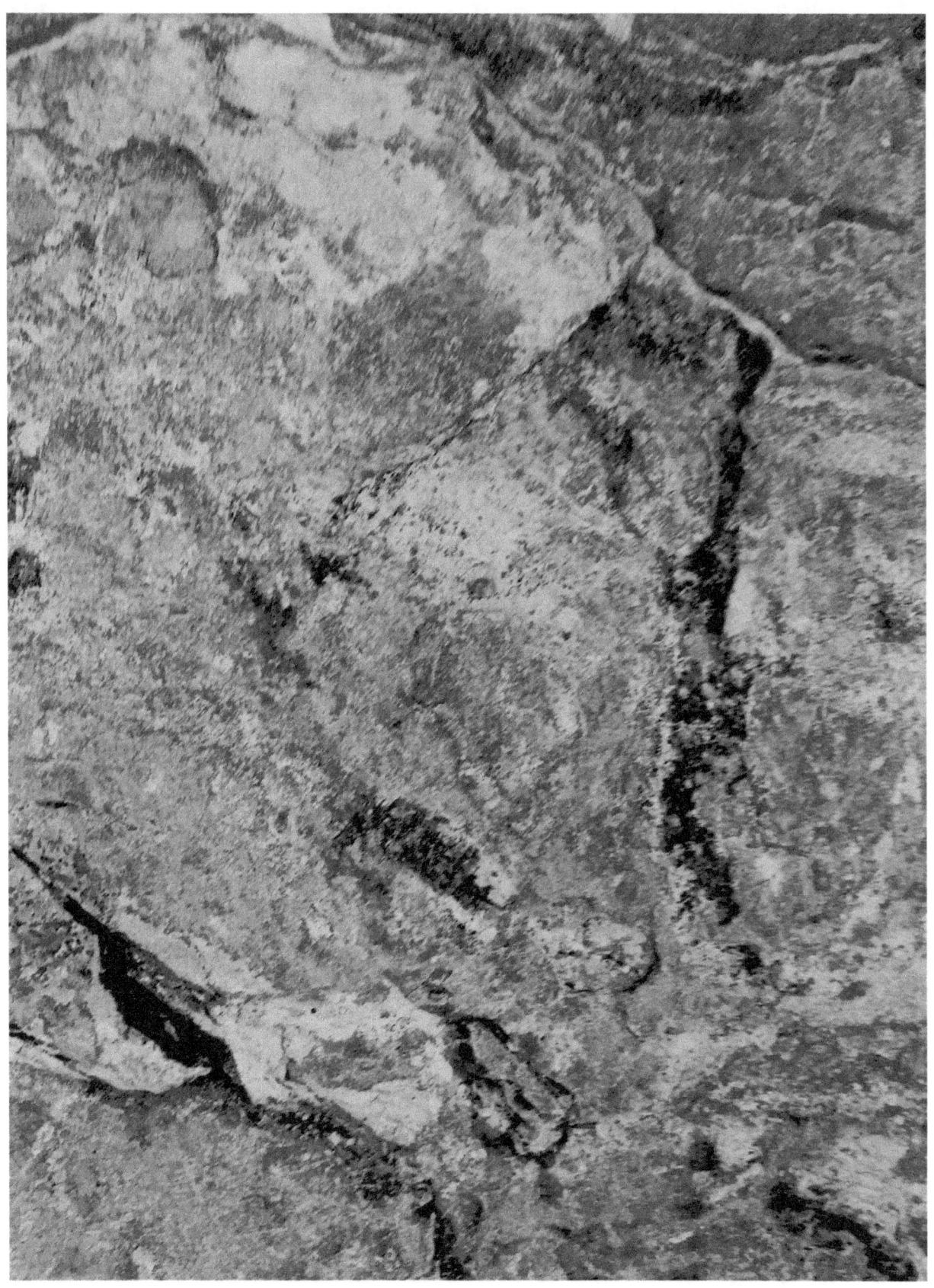

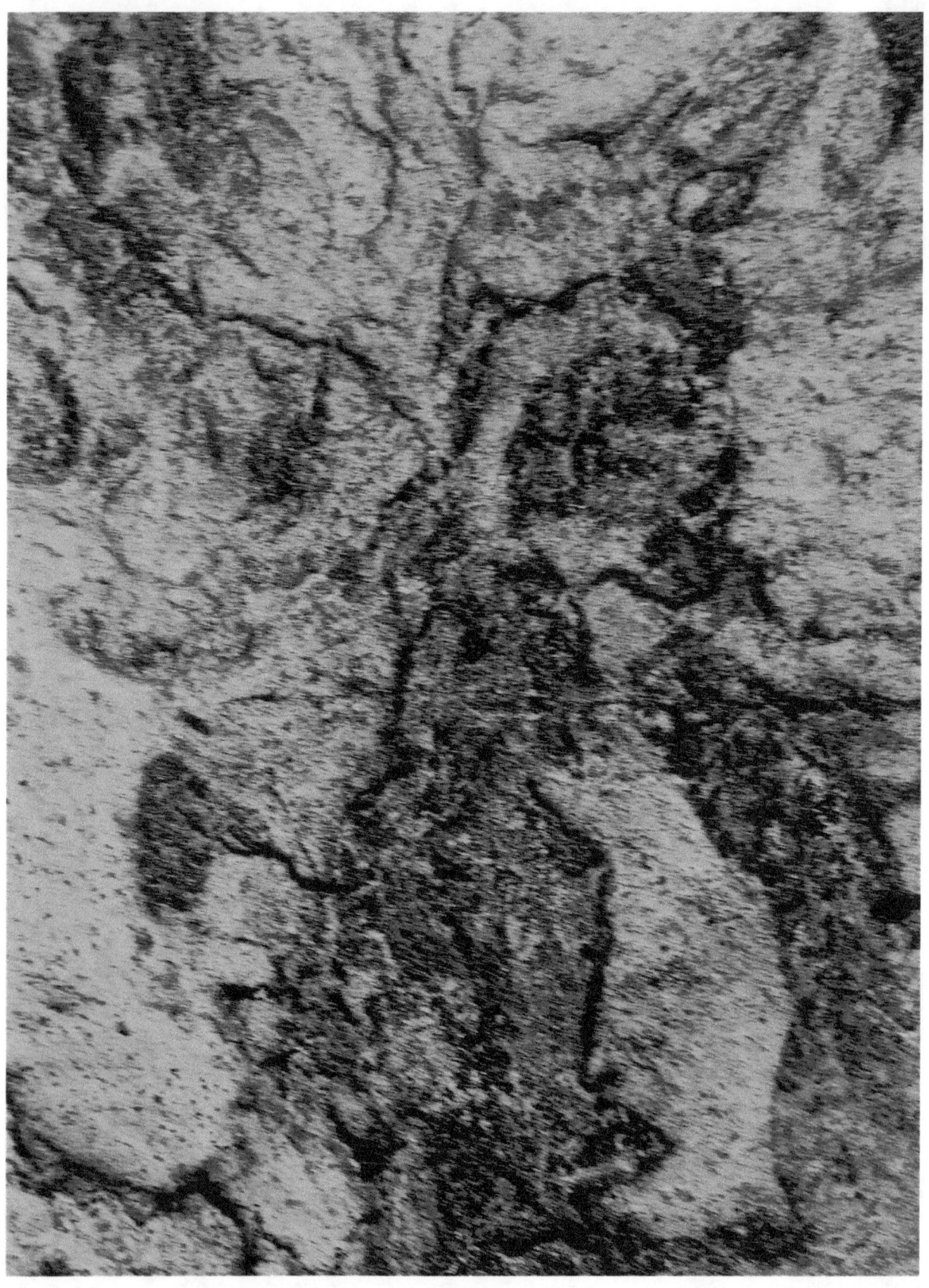

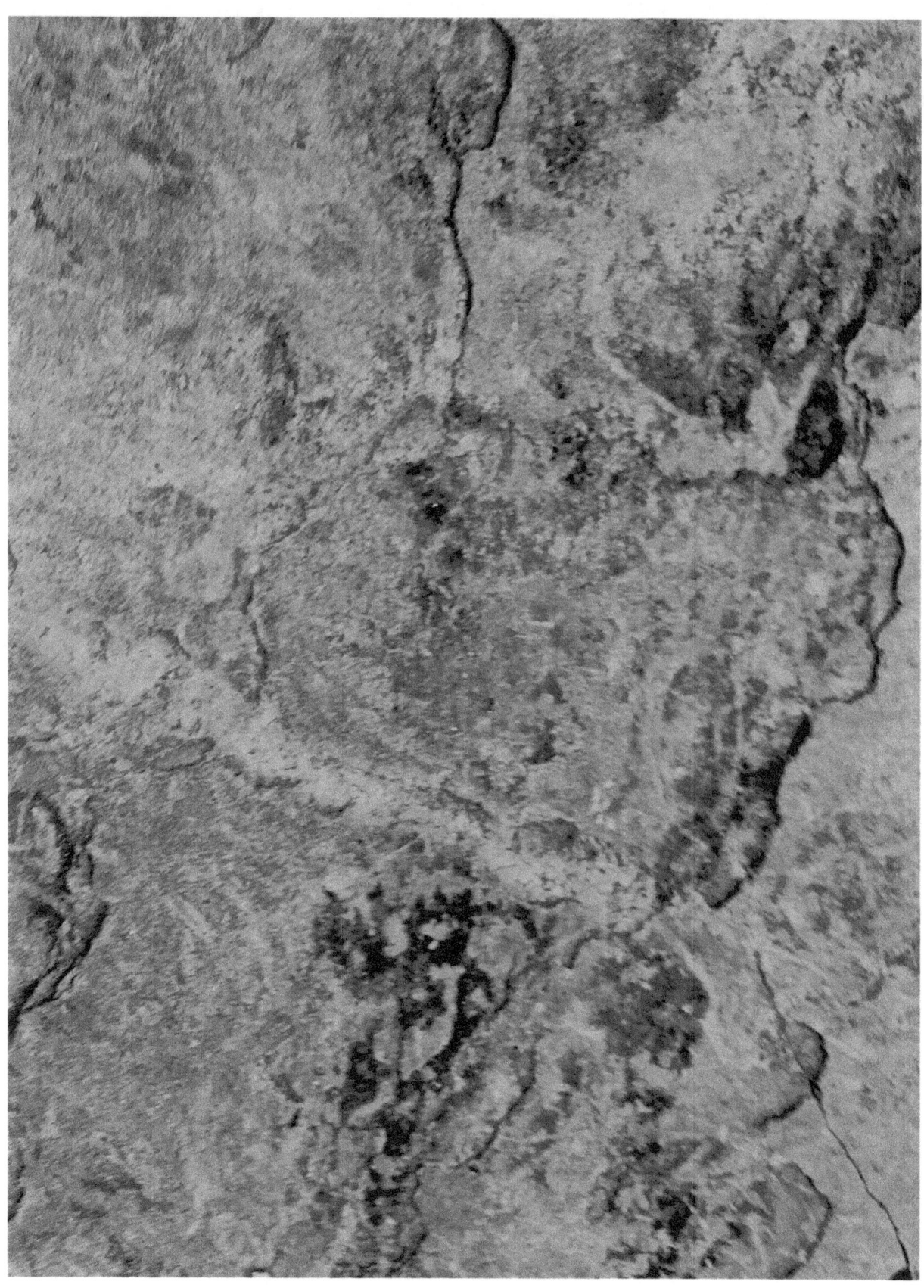

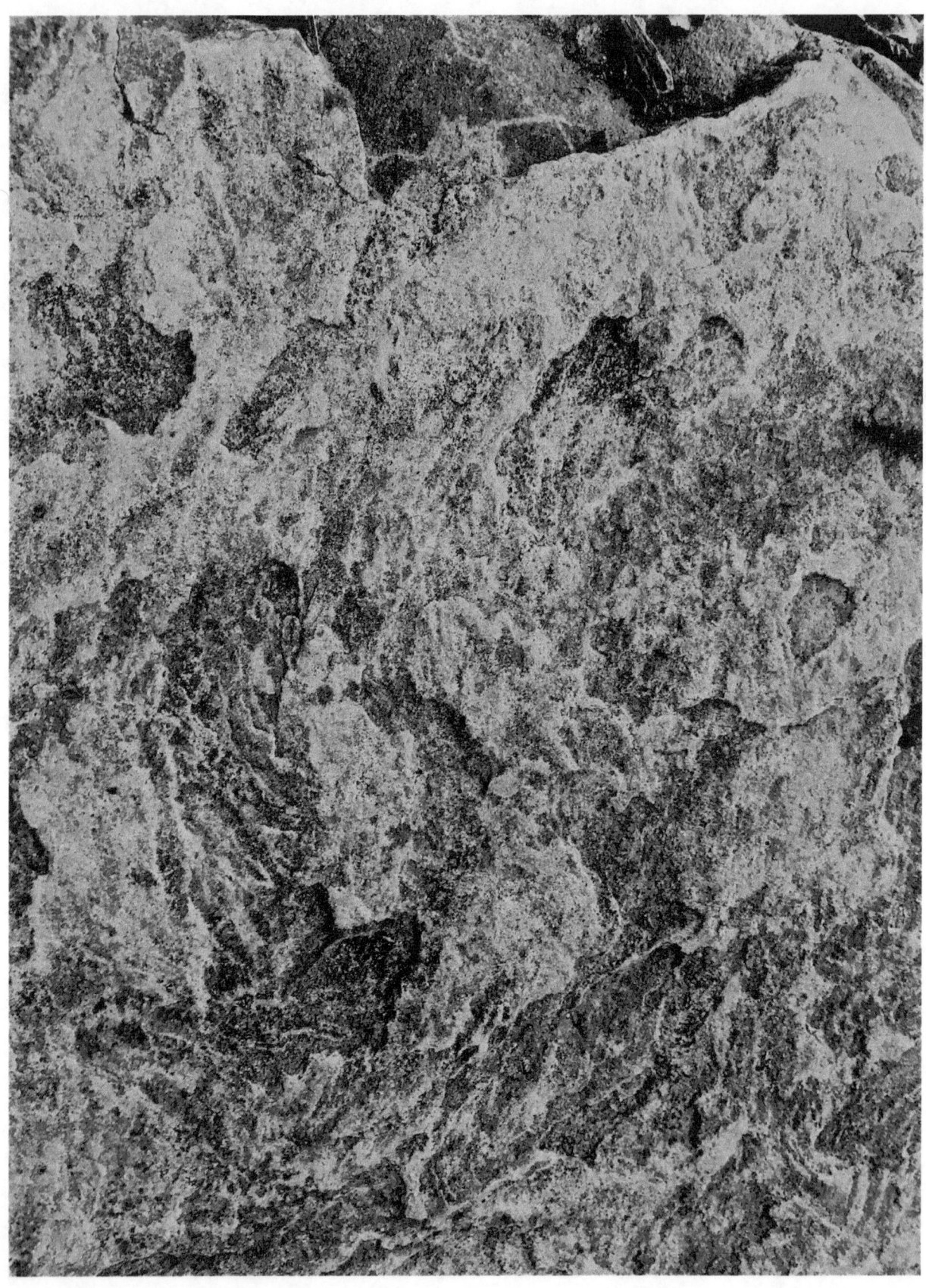

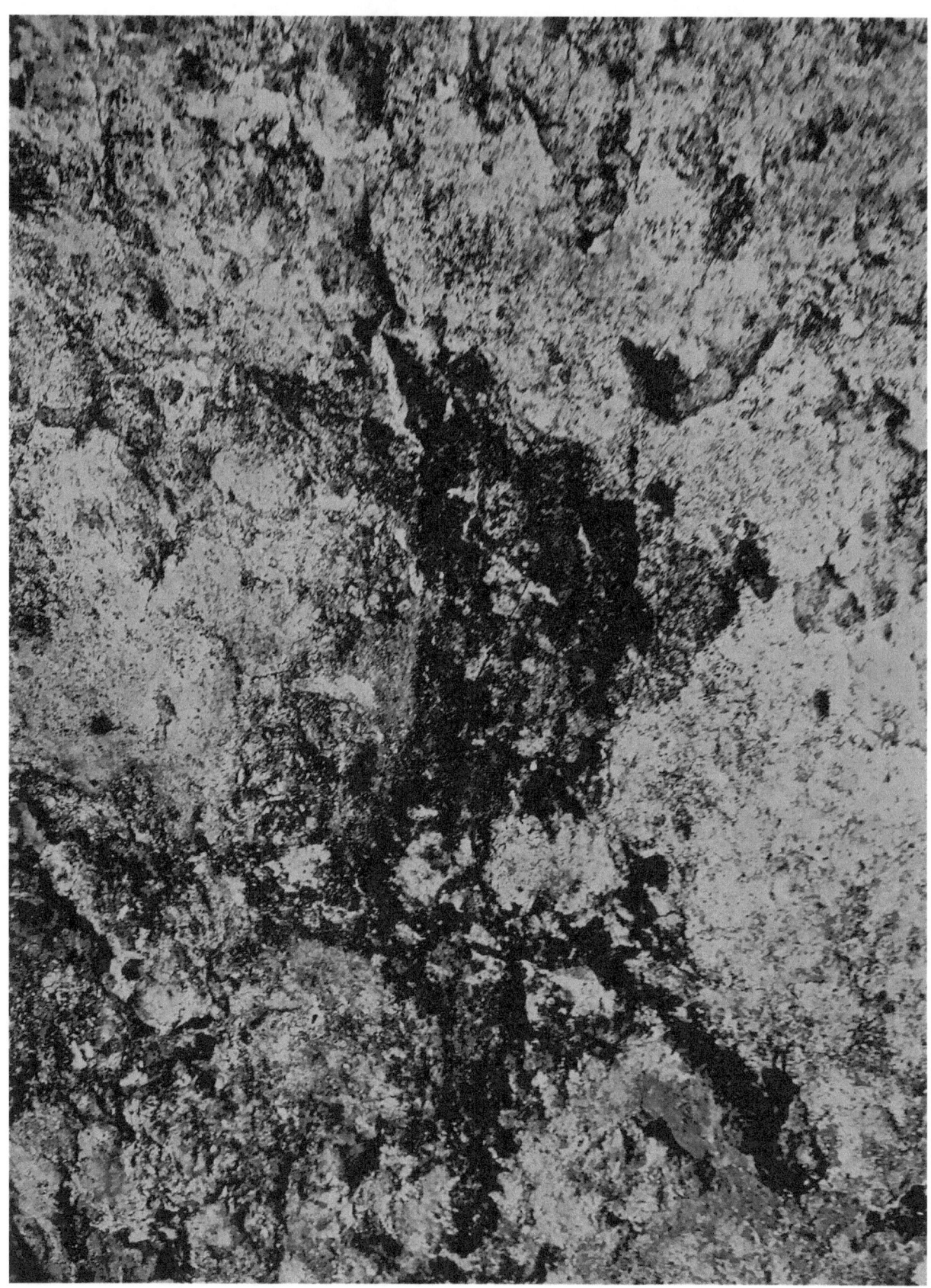

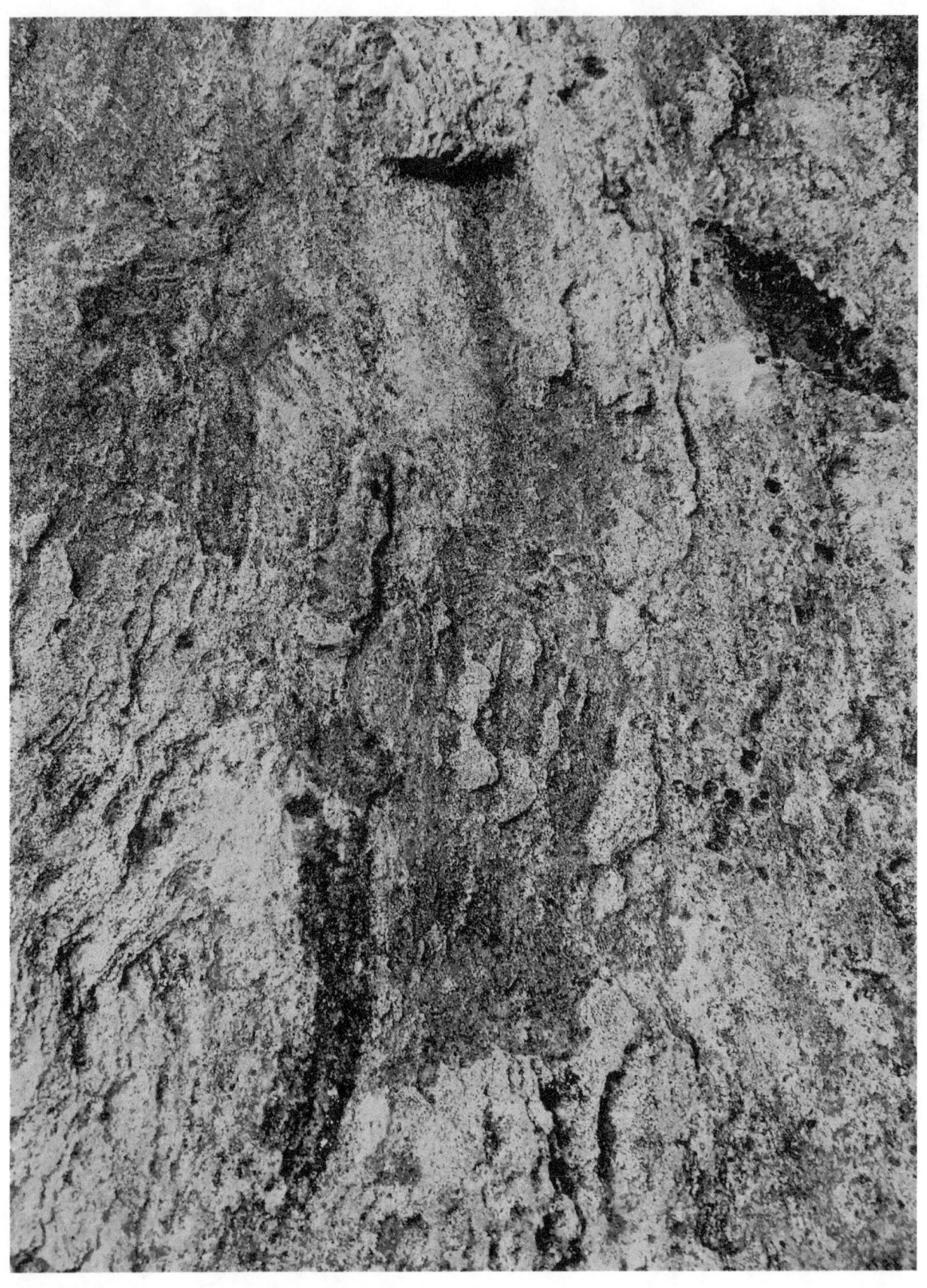

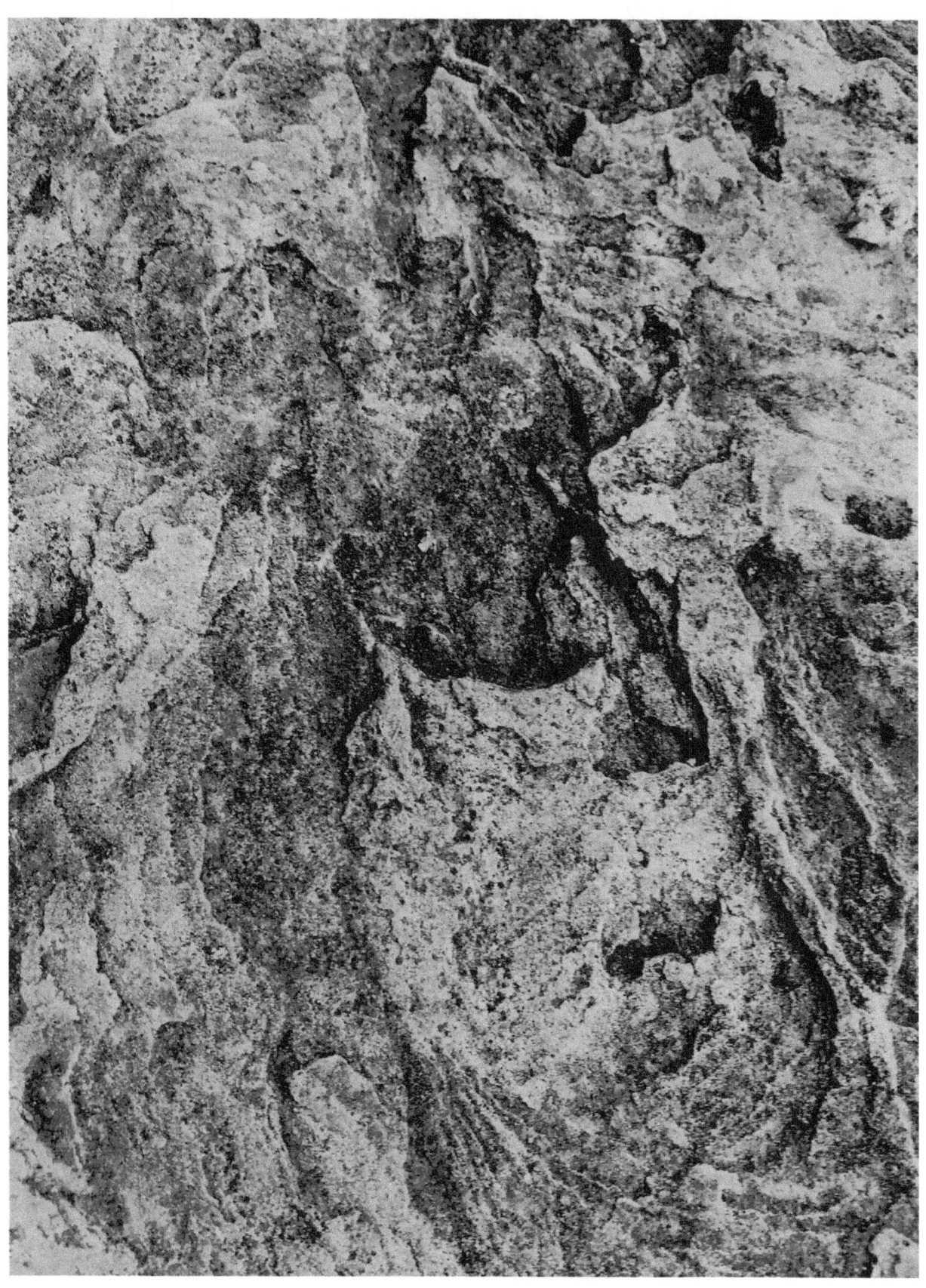

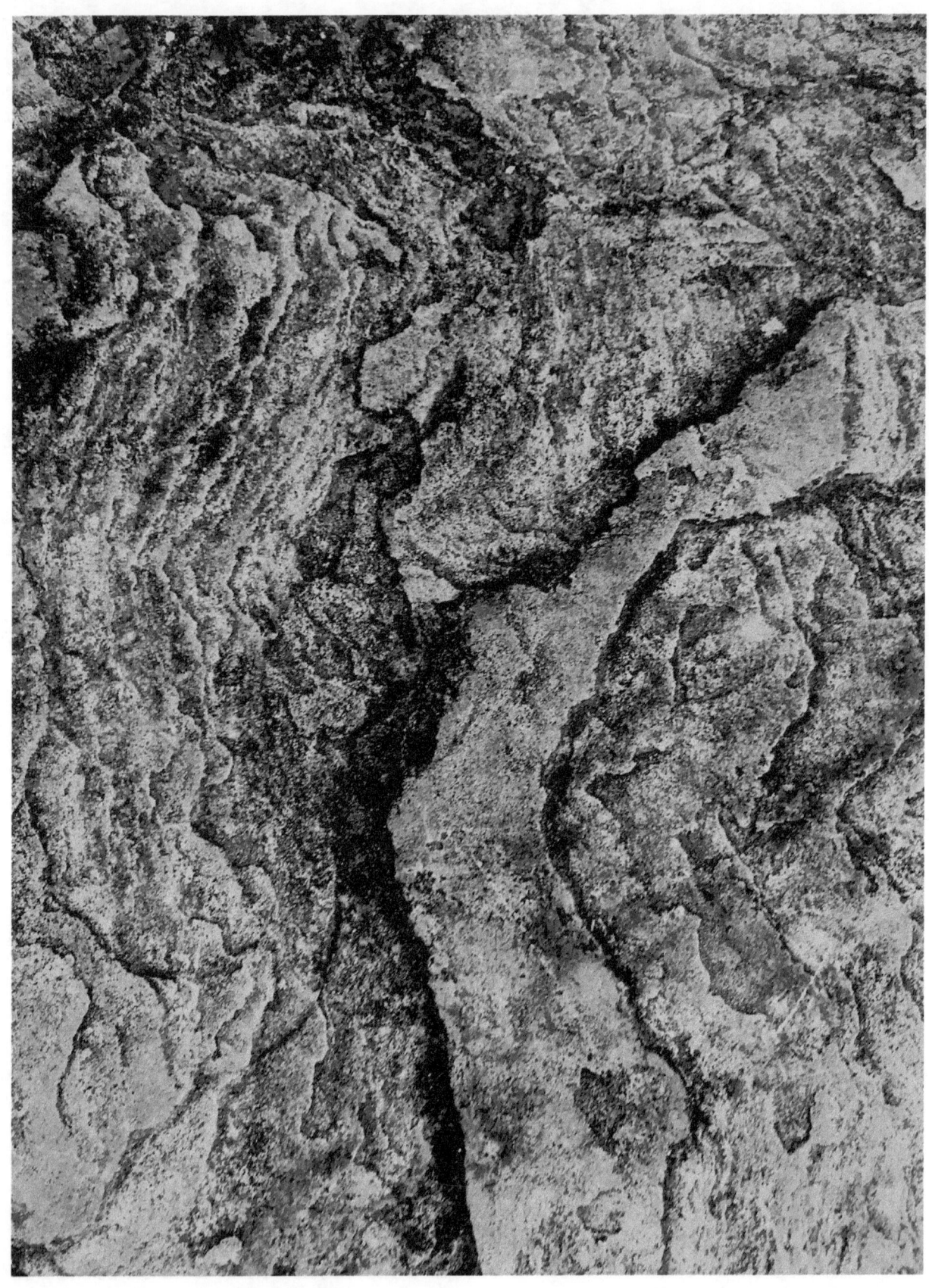

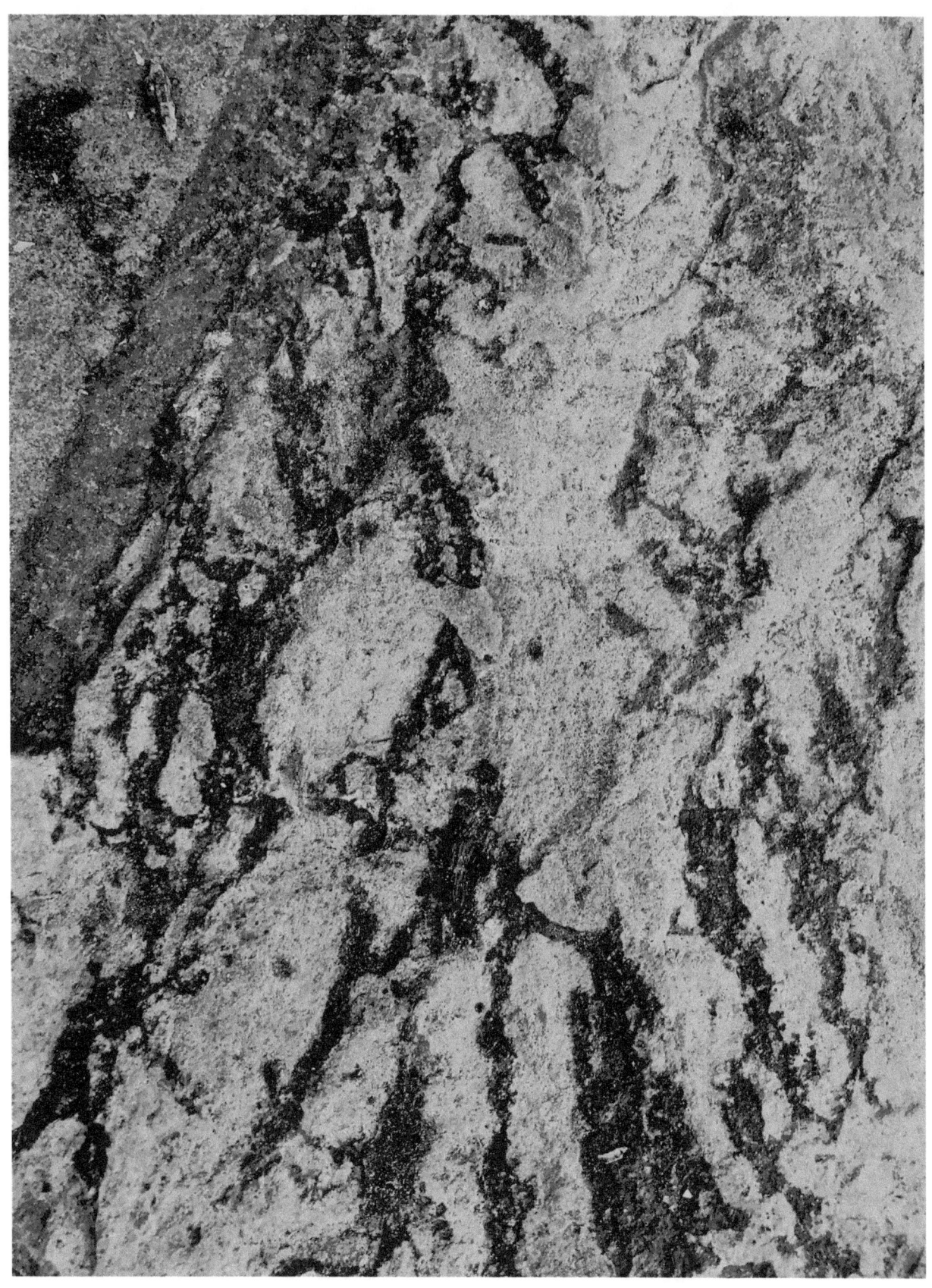

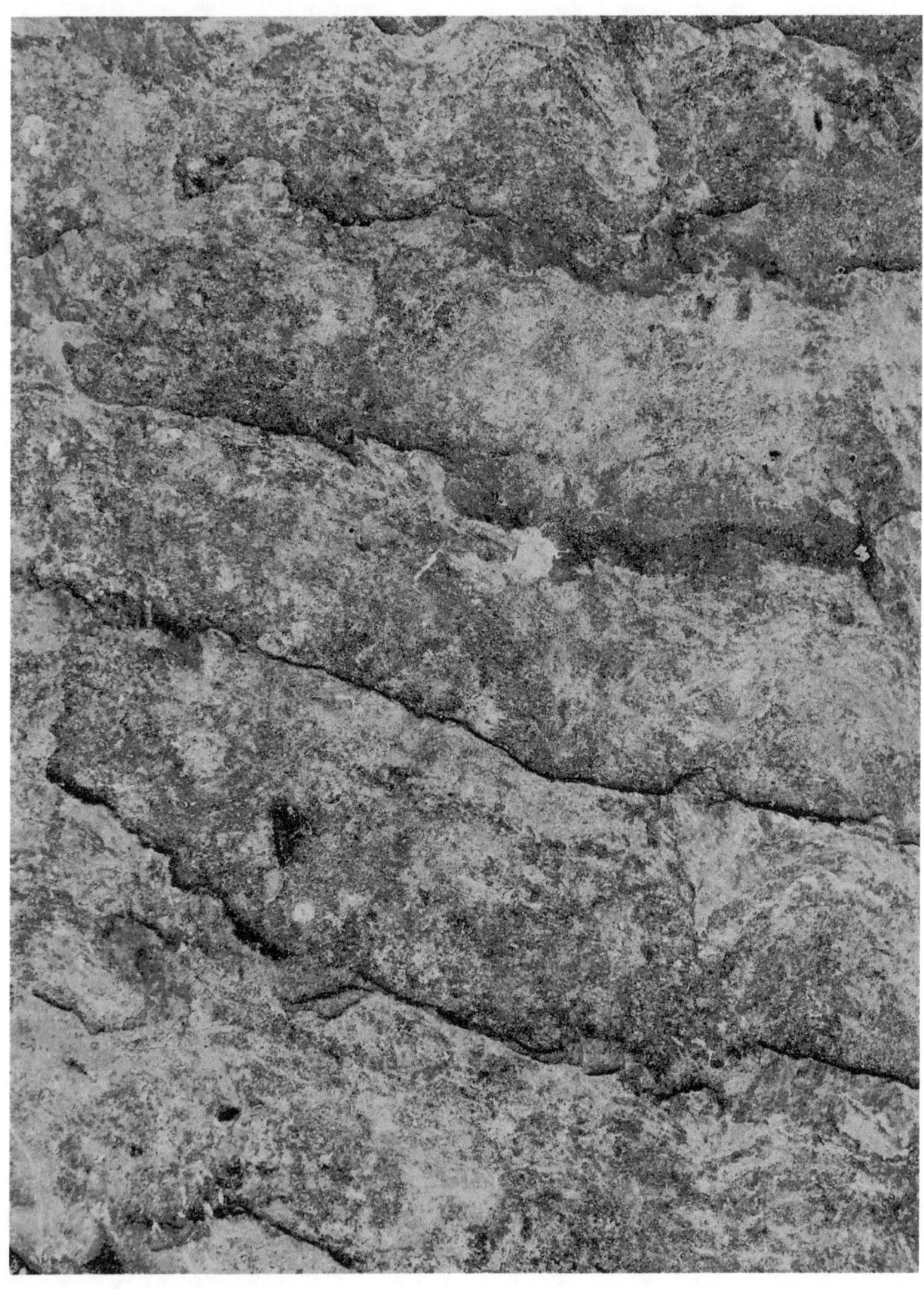

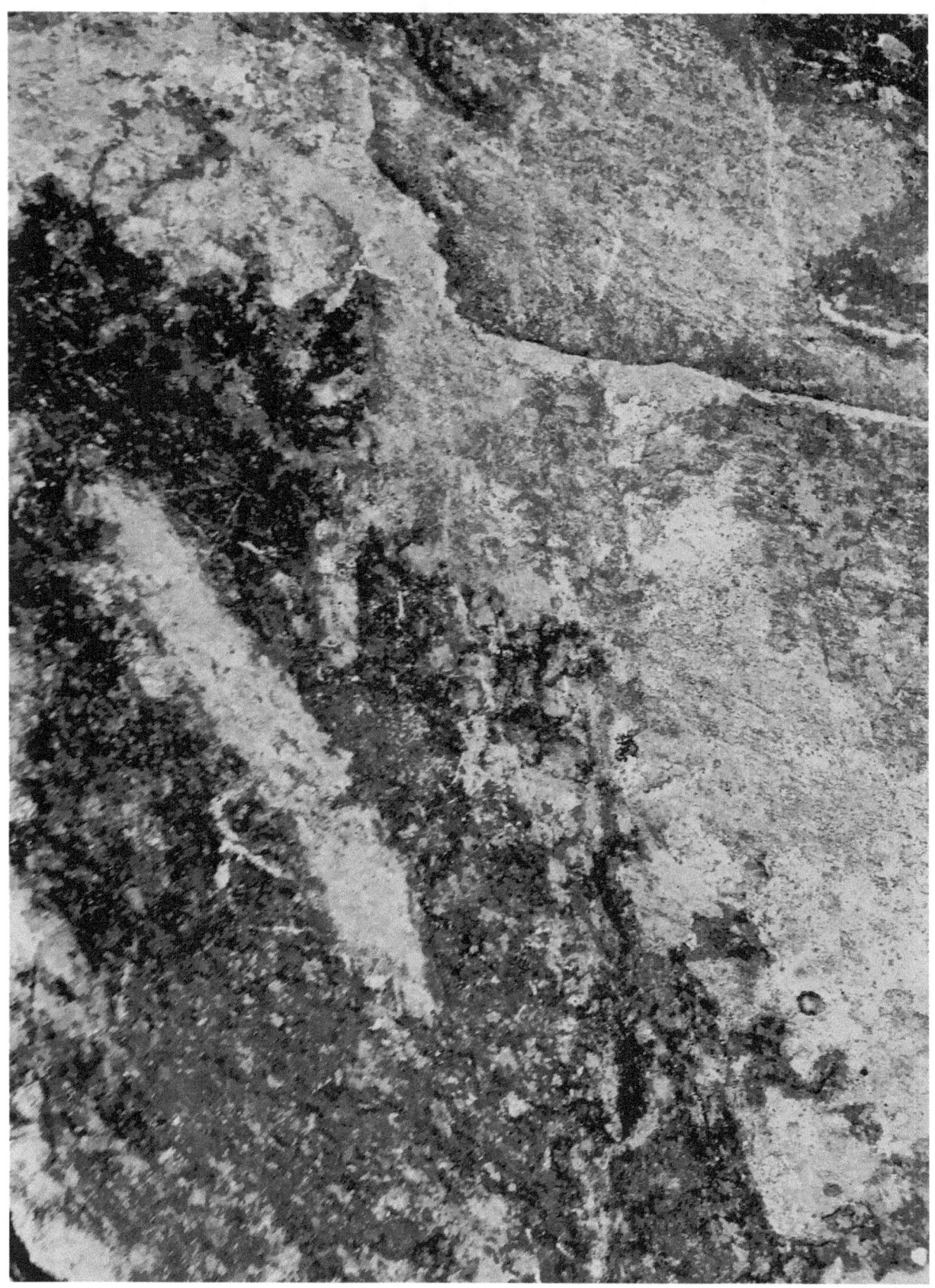

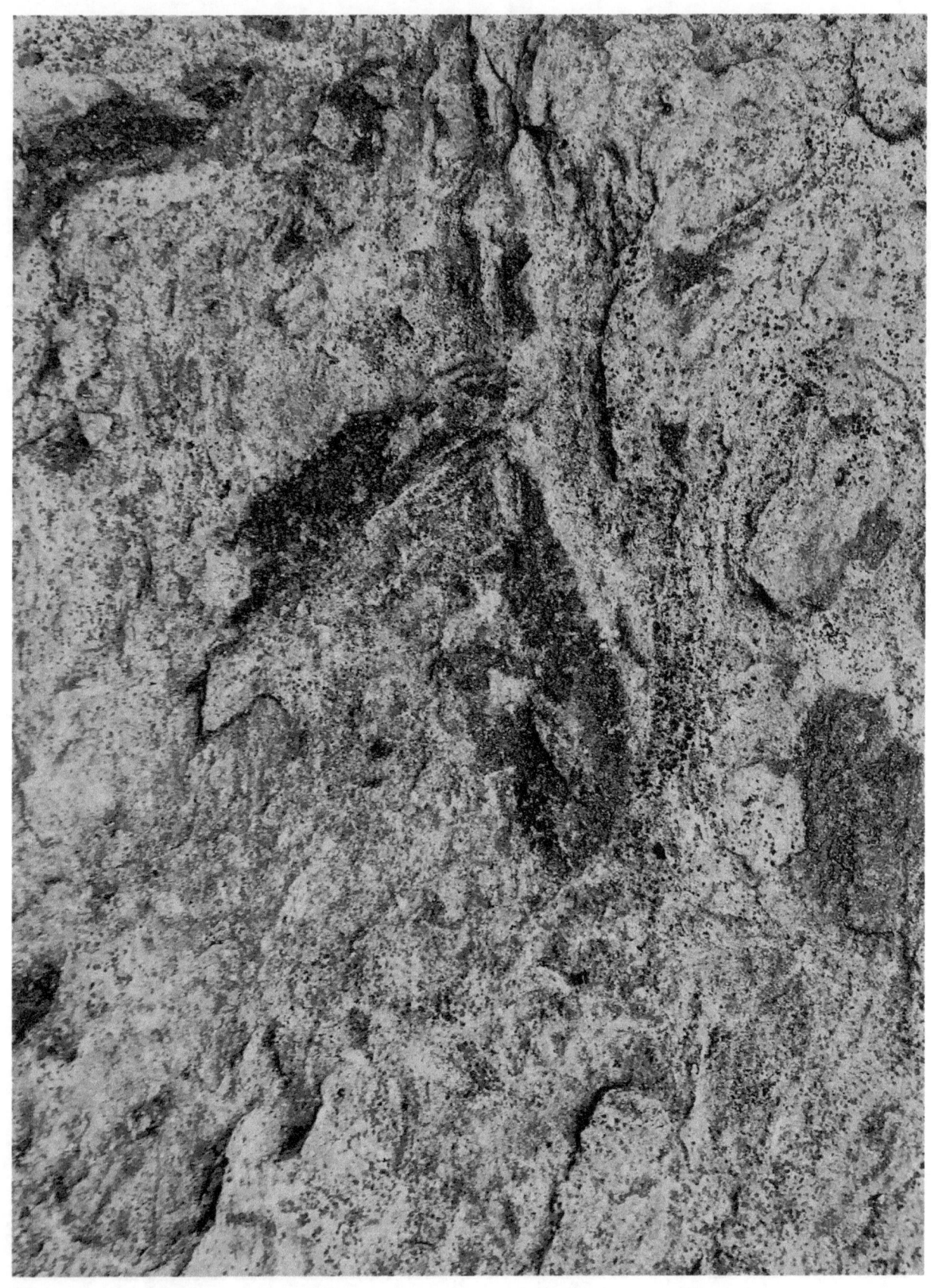

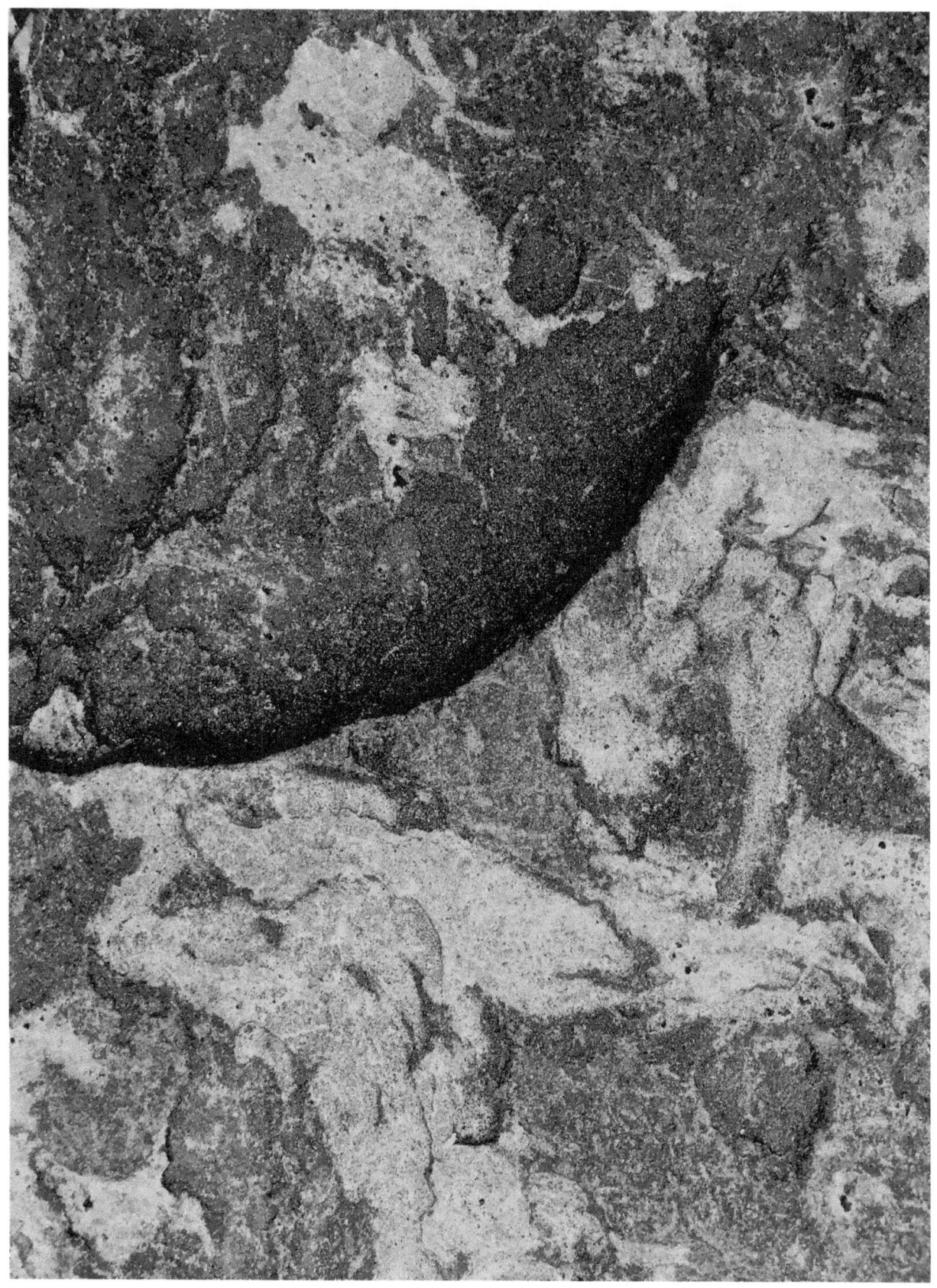

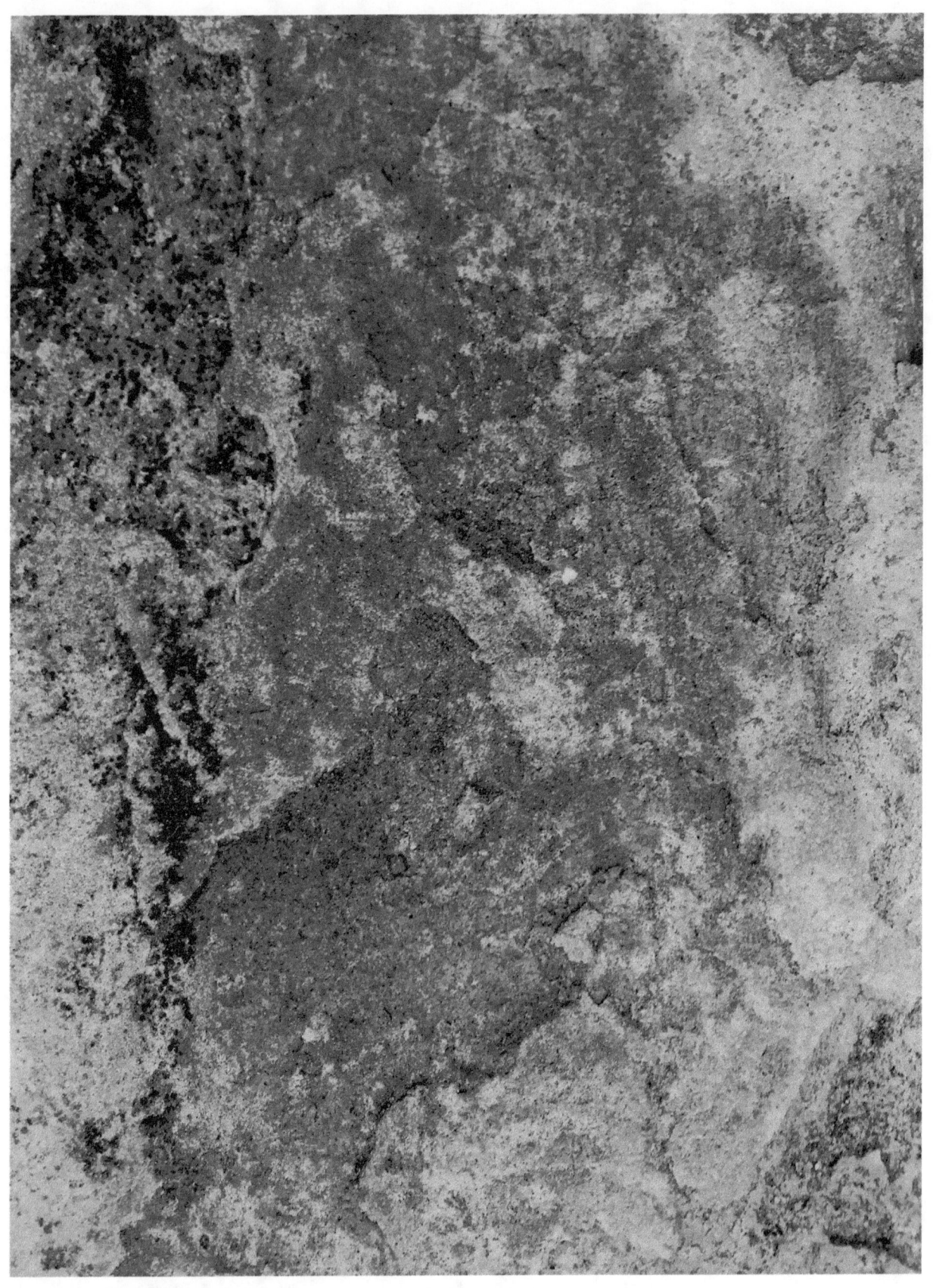

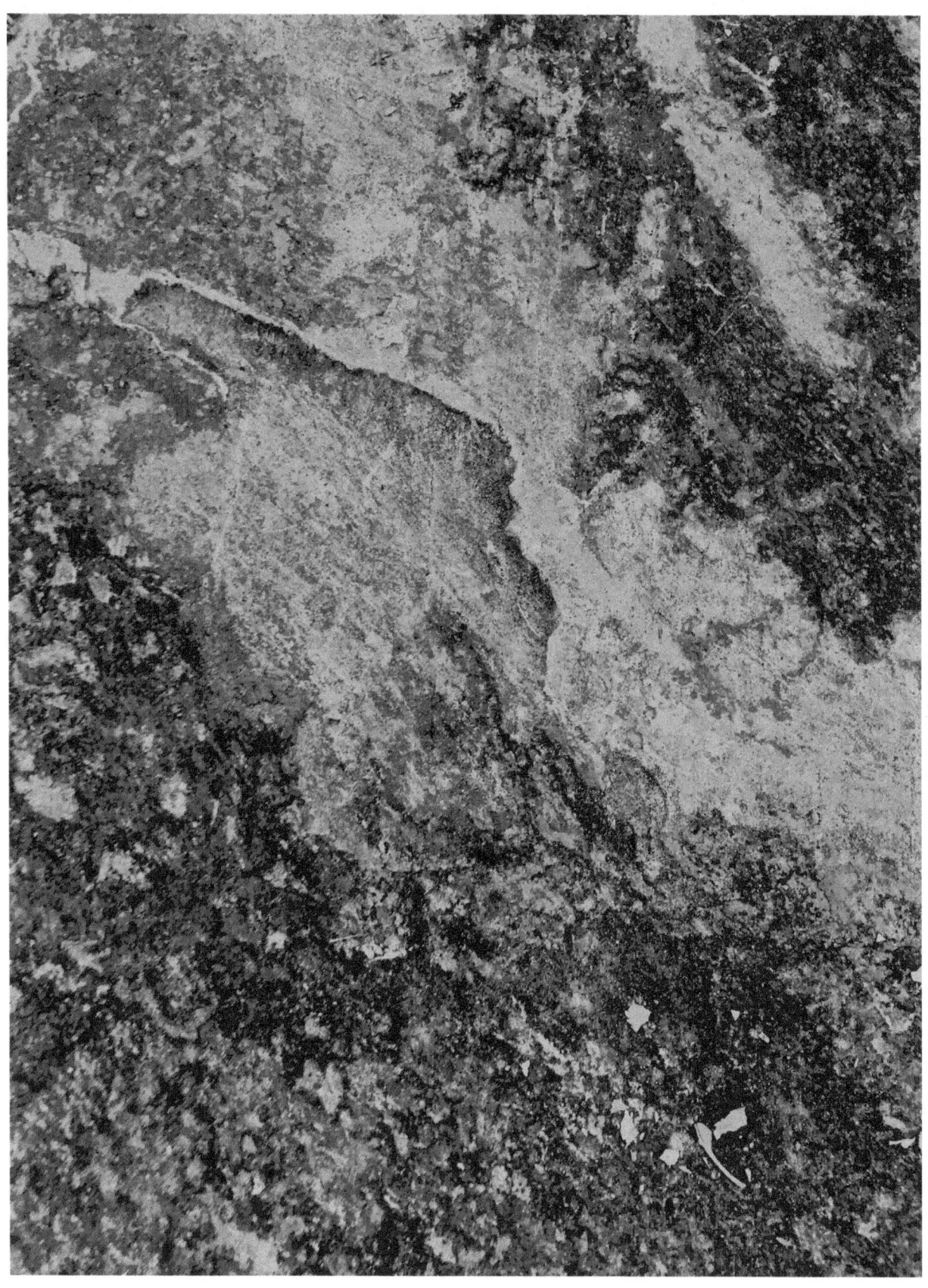

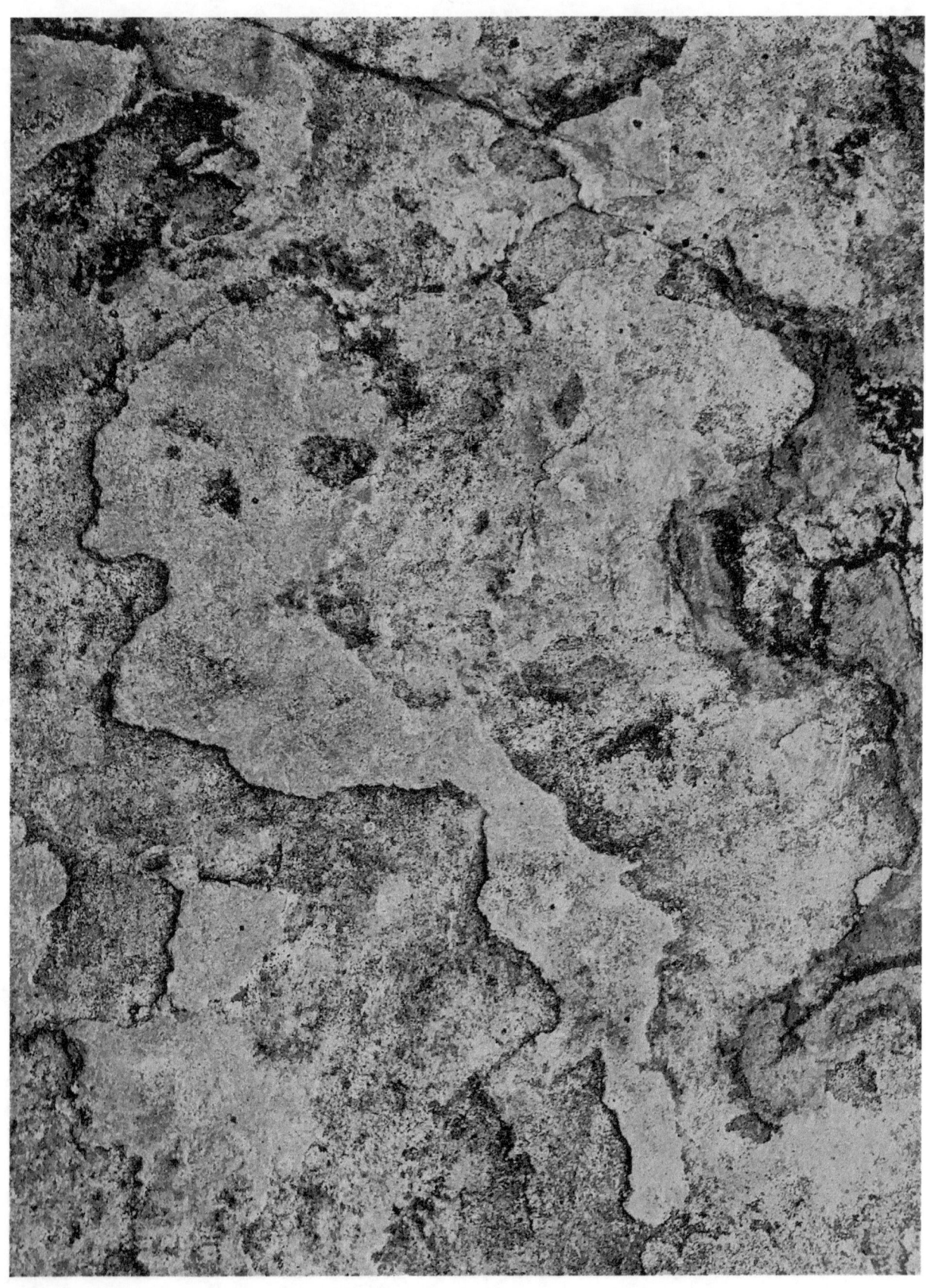